AMERICAN POWER

AMERICAN POWER

MITCH EPSTEIN

STEIDL

FOR LUCIA

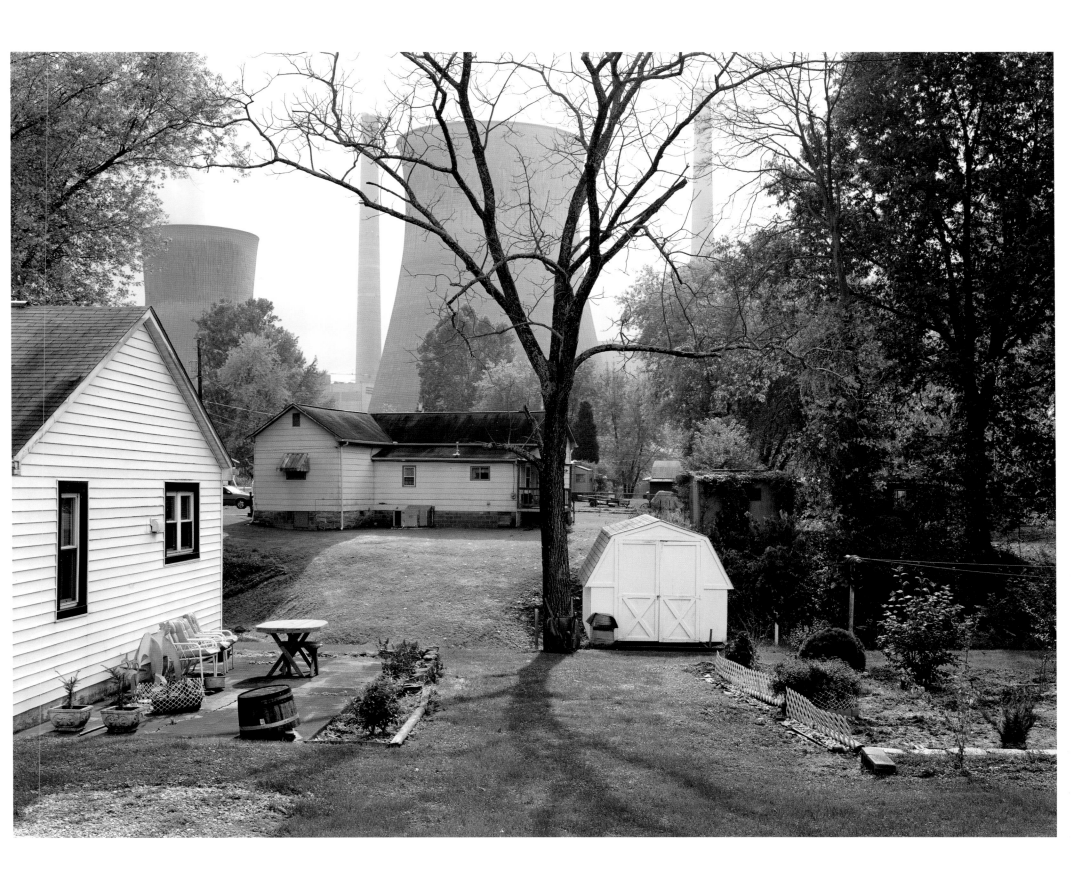

Poca High School and Amos Coal Power Plant, West Virginia 2004

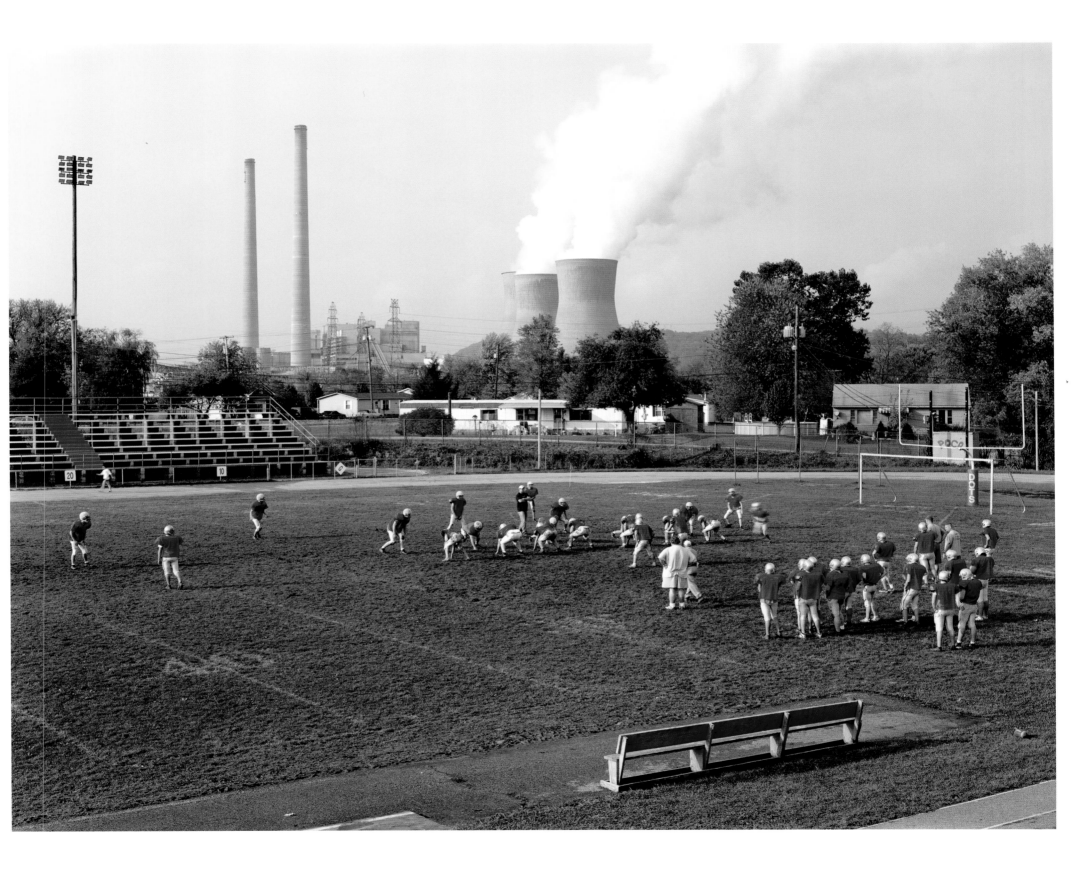

3 BP Carson Refinery, California 2007

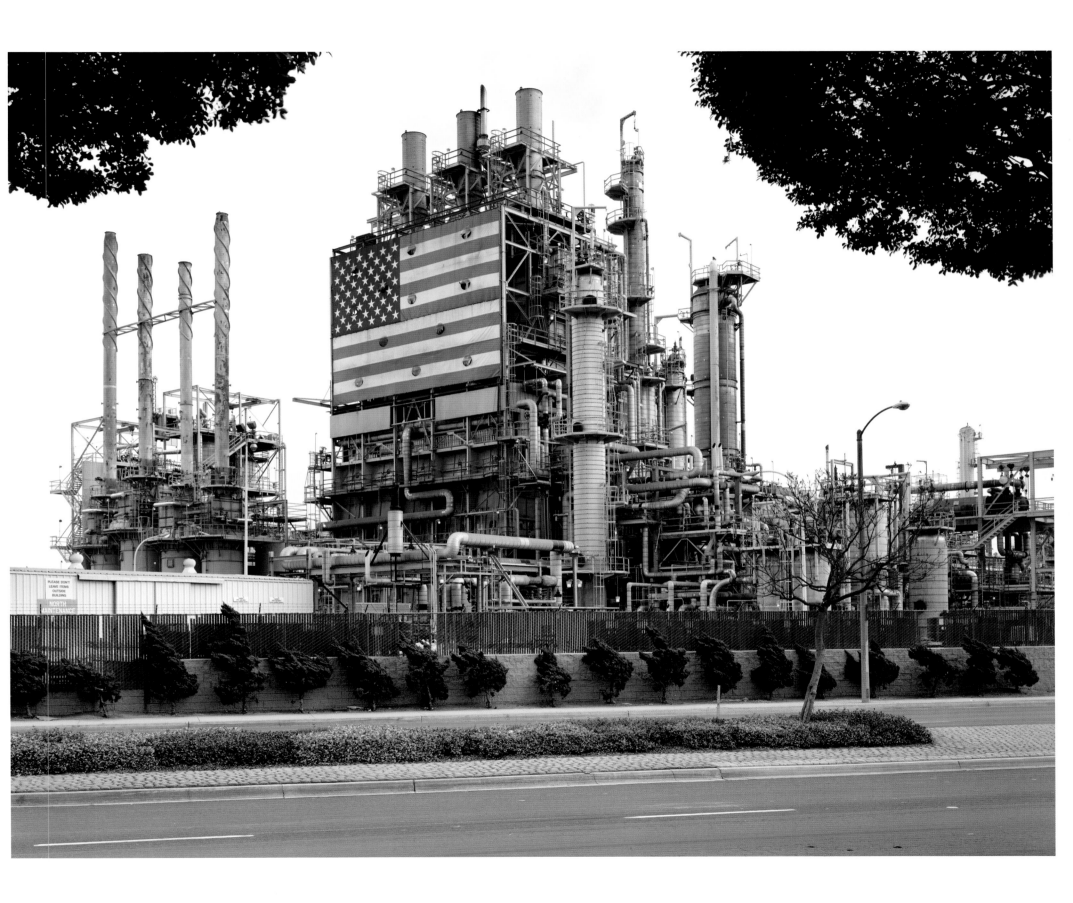

4 Amos Coal Power Plant III, Winfield, West Virginia 2007

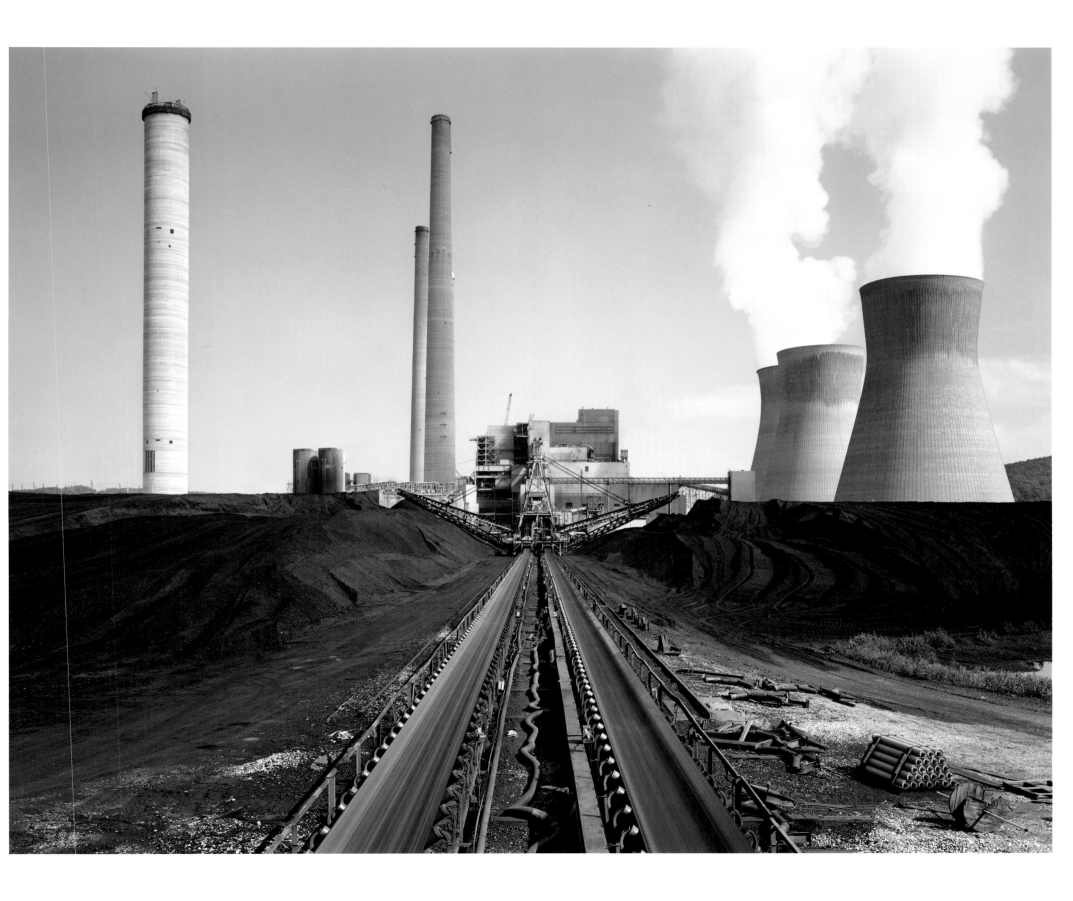

Vogtle Nuclear Power Plant, Waynesboro, Georgia 2006

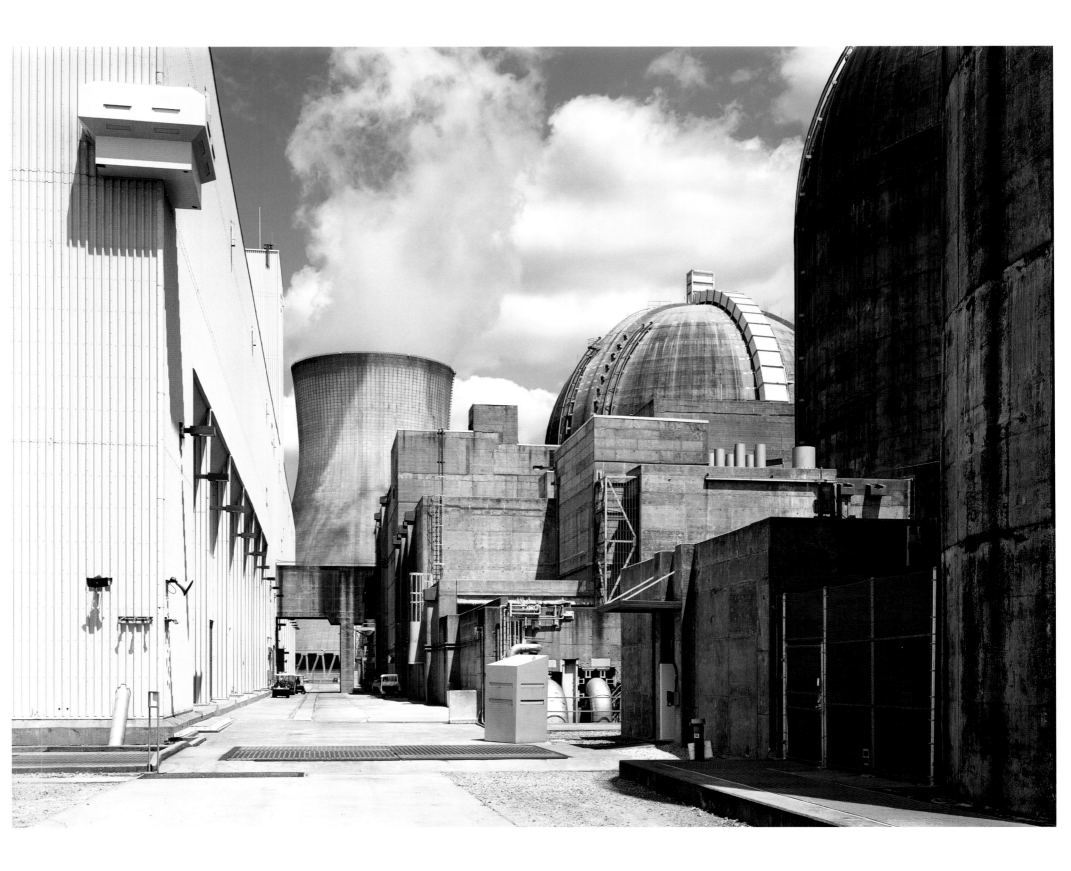

6 Gavin Coal Power Plant, Cheshire, Ohio 2003

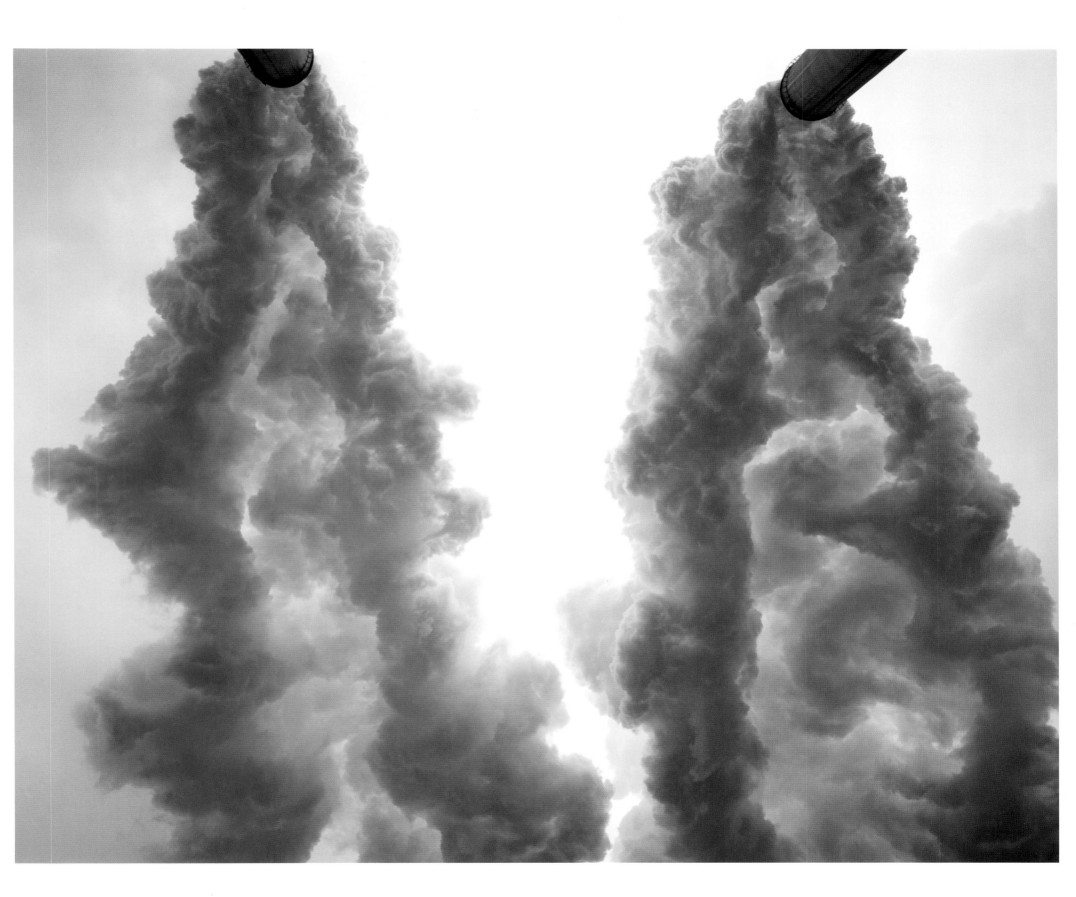

7 Cheshire, Ohio 2004

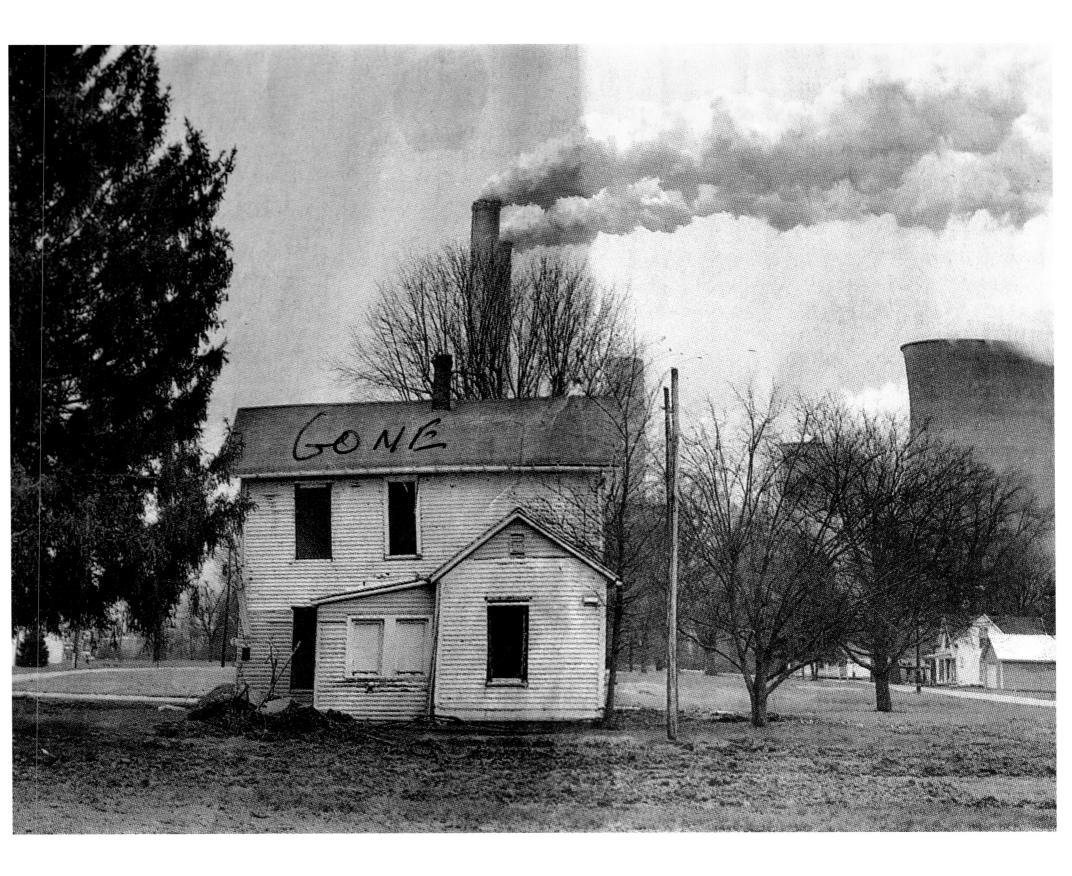

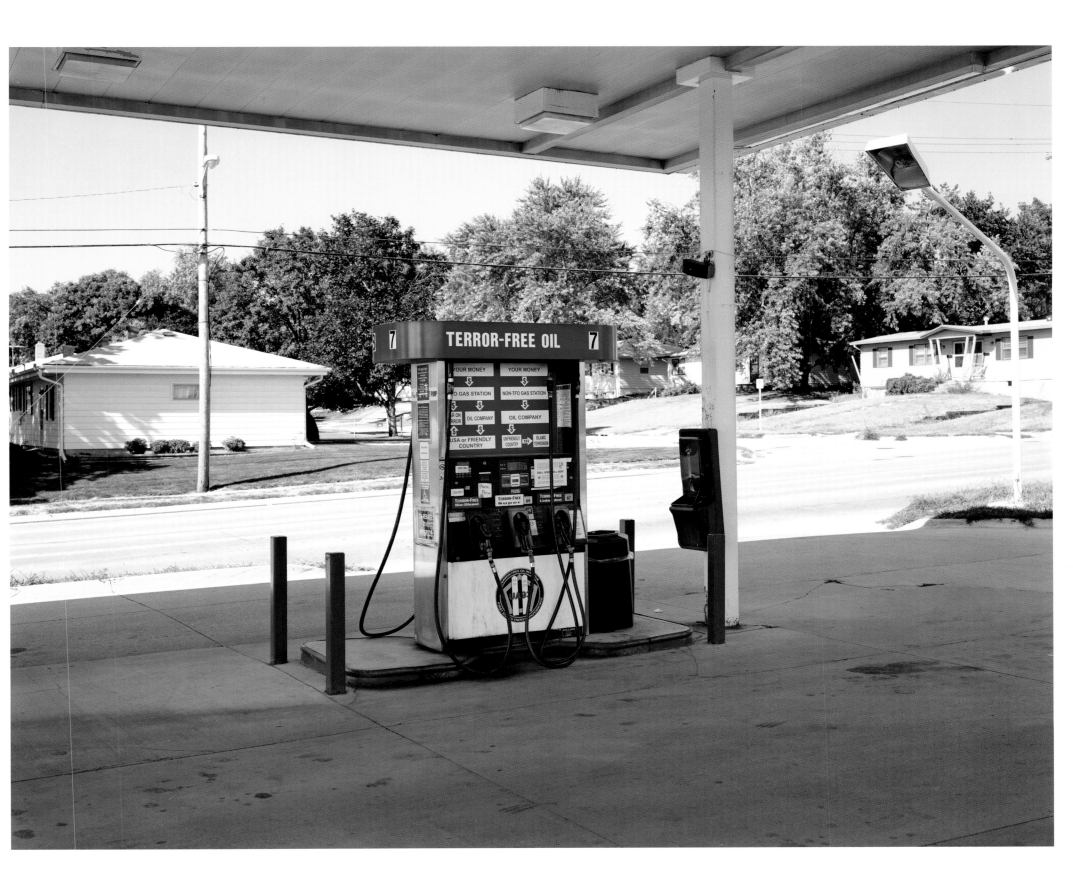

9 Beulah "Boots" Hern, Cheshire, Ohio 2004

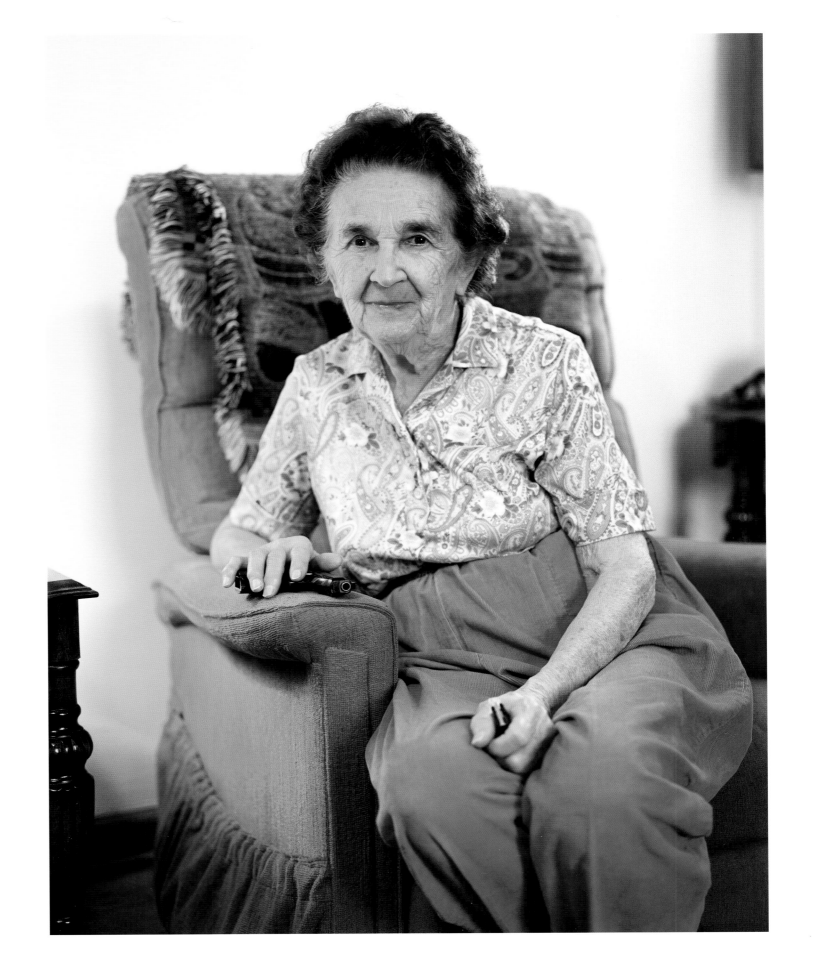

10 Beulah "Boots" Hern's House, Cheshire, Ohio 2004

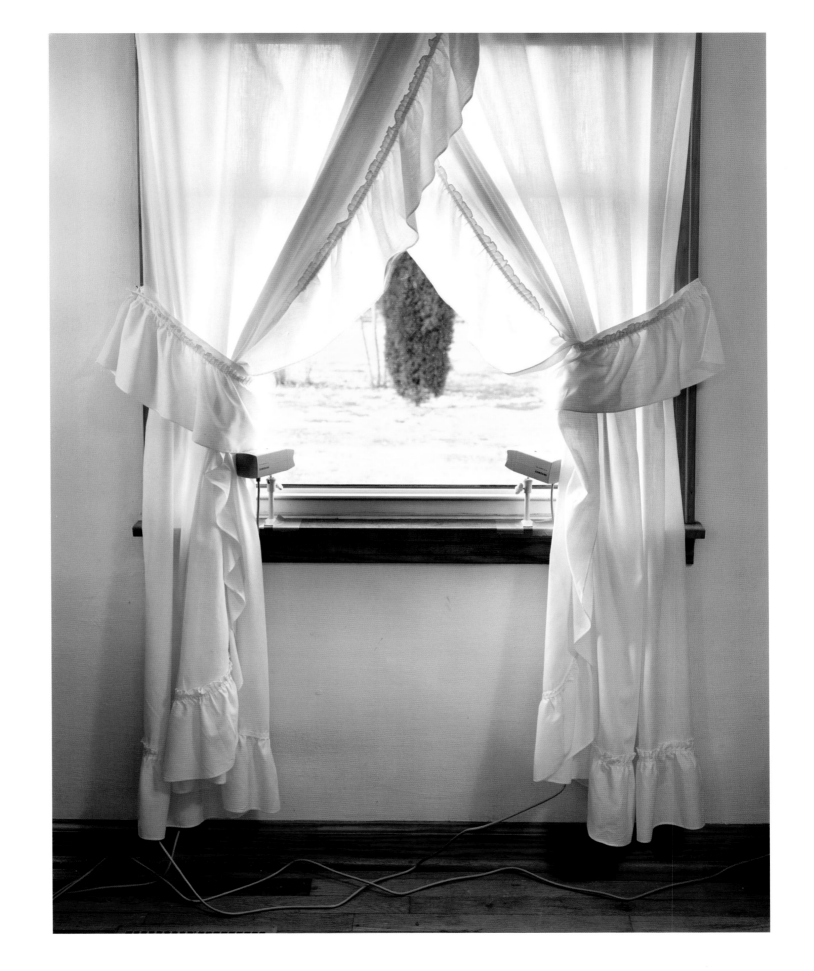

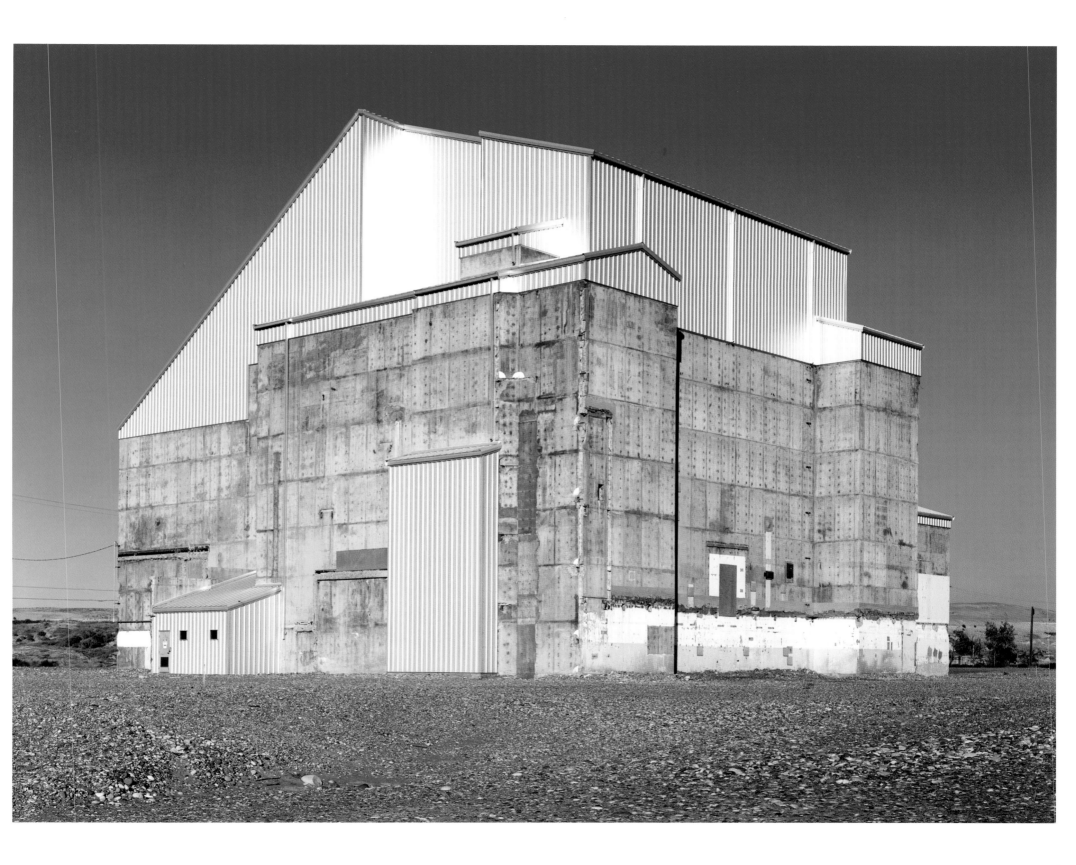

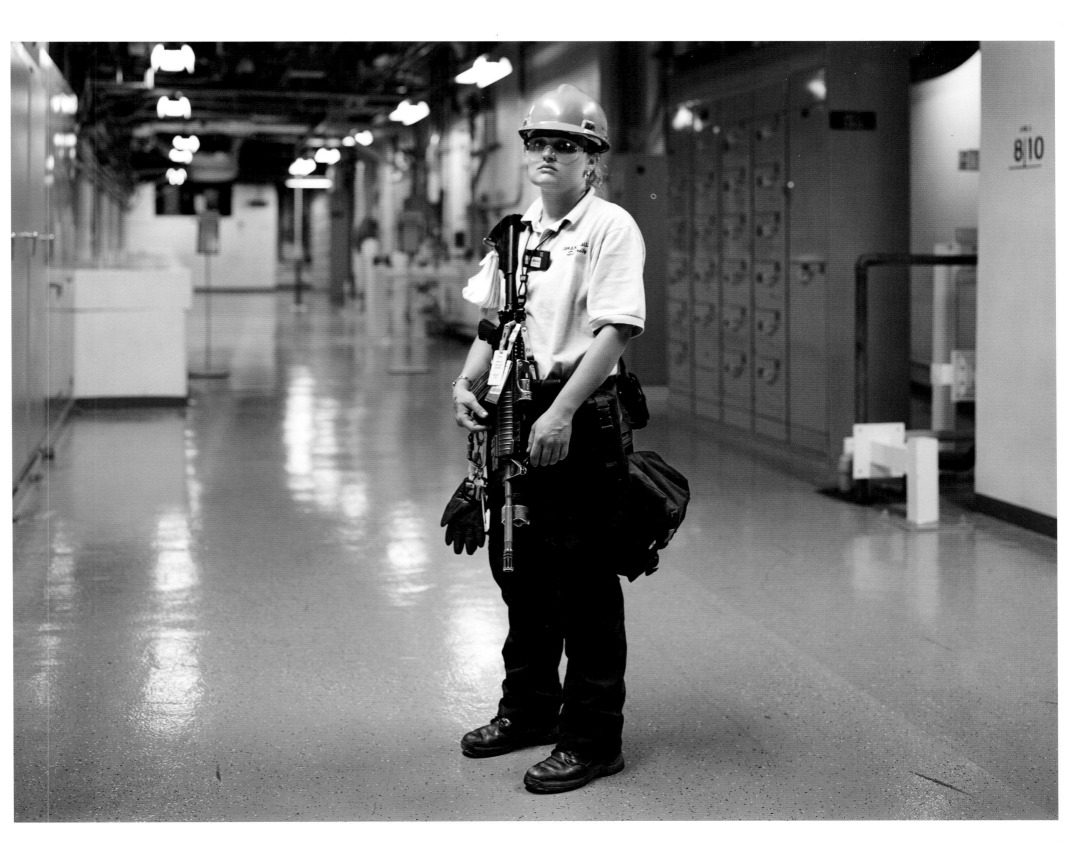

13 Grand Gulf Nuclear Regulatory Office, Mississippi II 2006

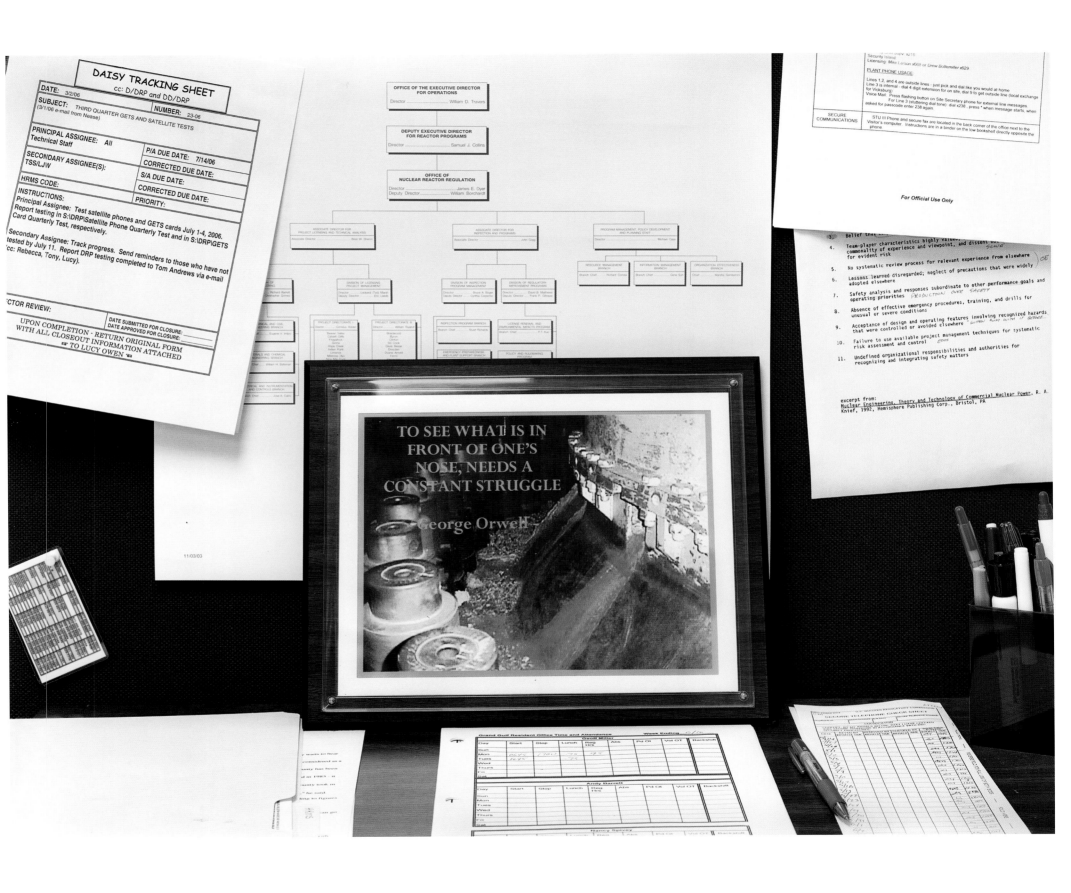

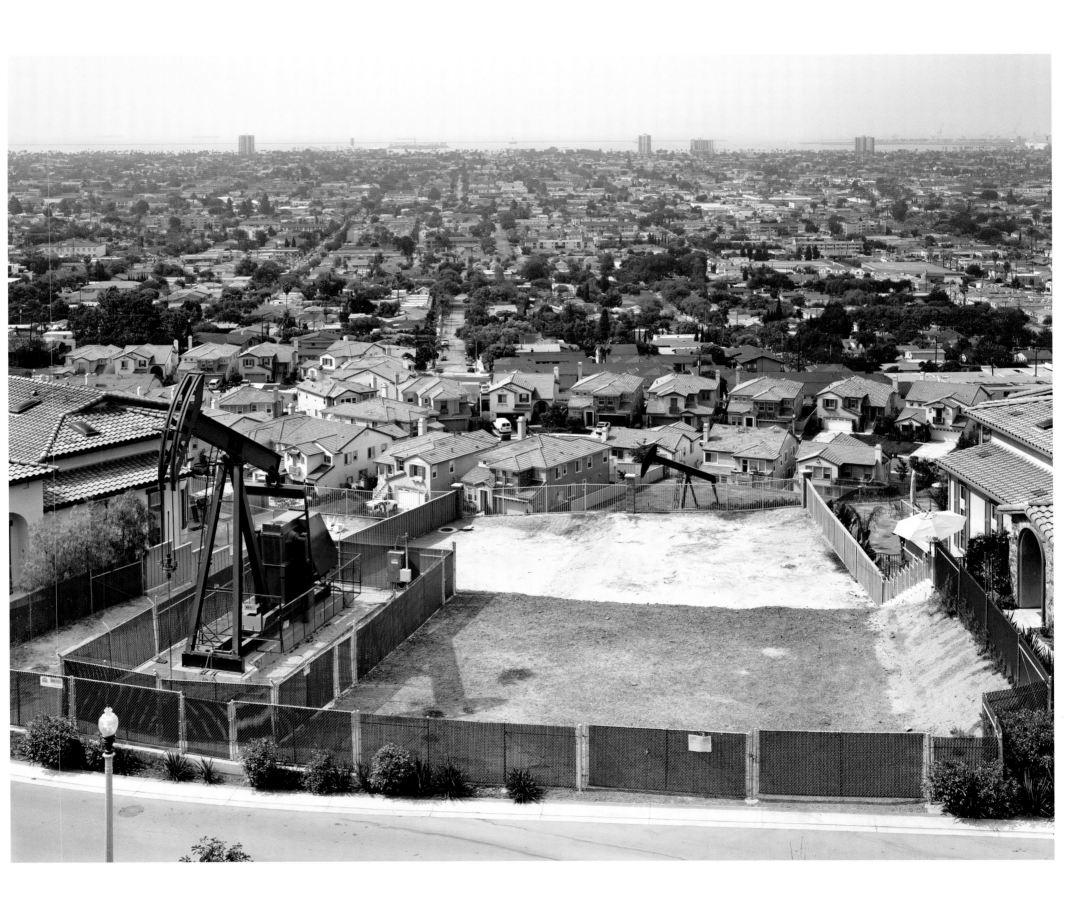

15 Wyodak Coal Mine, Wyoming 2008

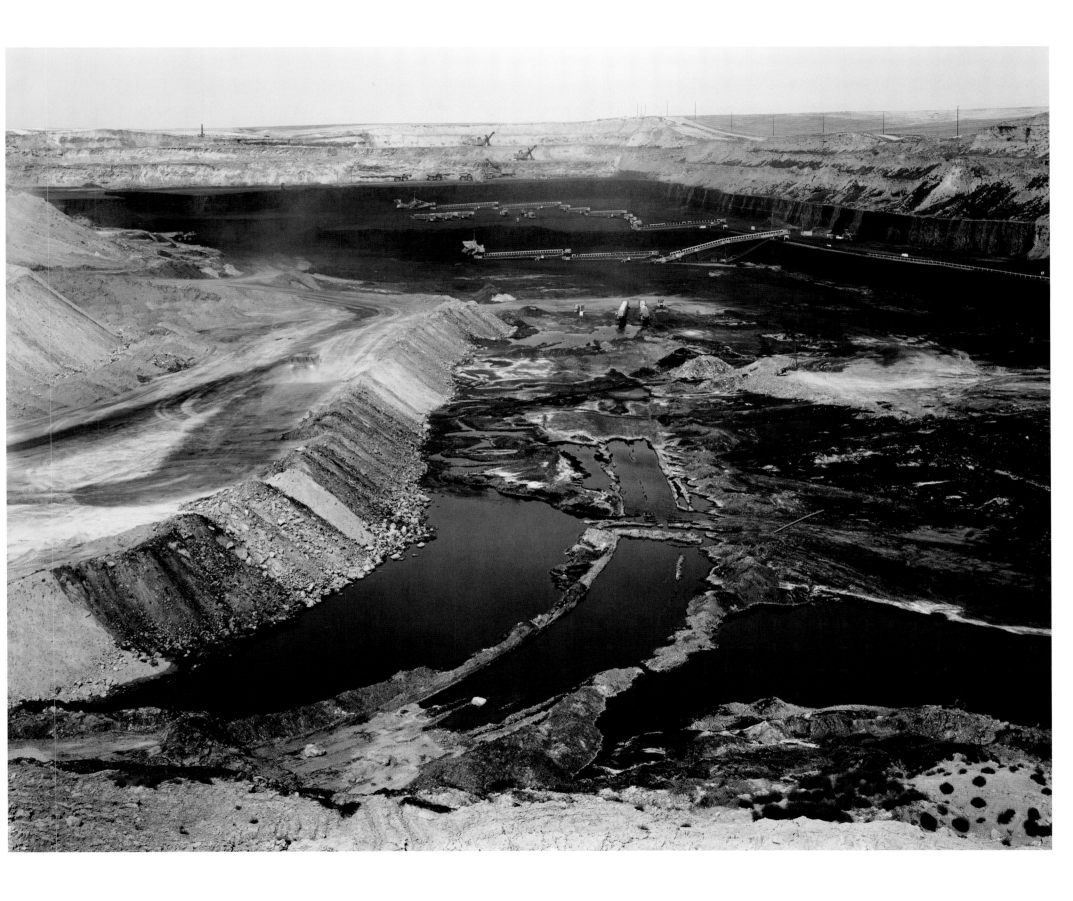

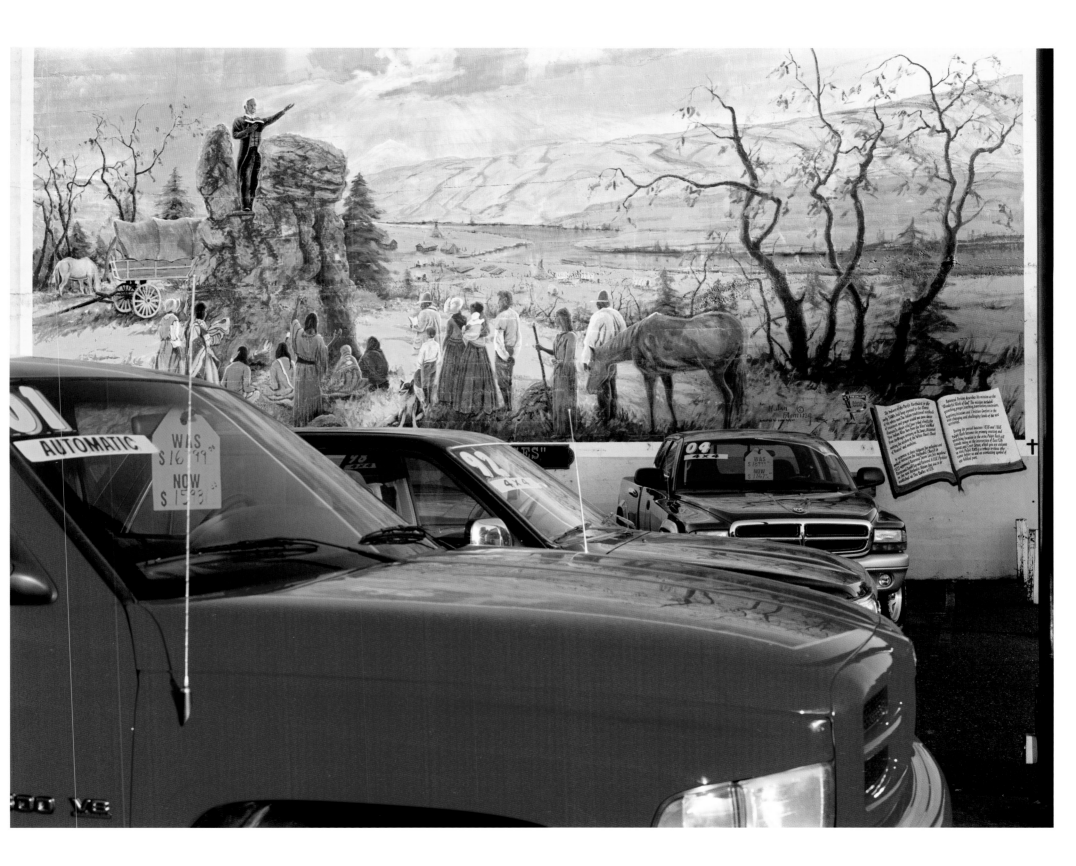

17 Rancho Seco Nuclear Power Plant, Herald, California 2005

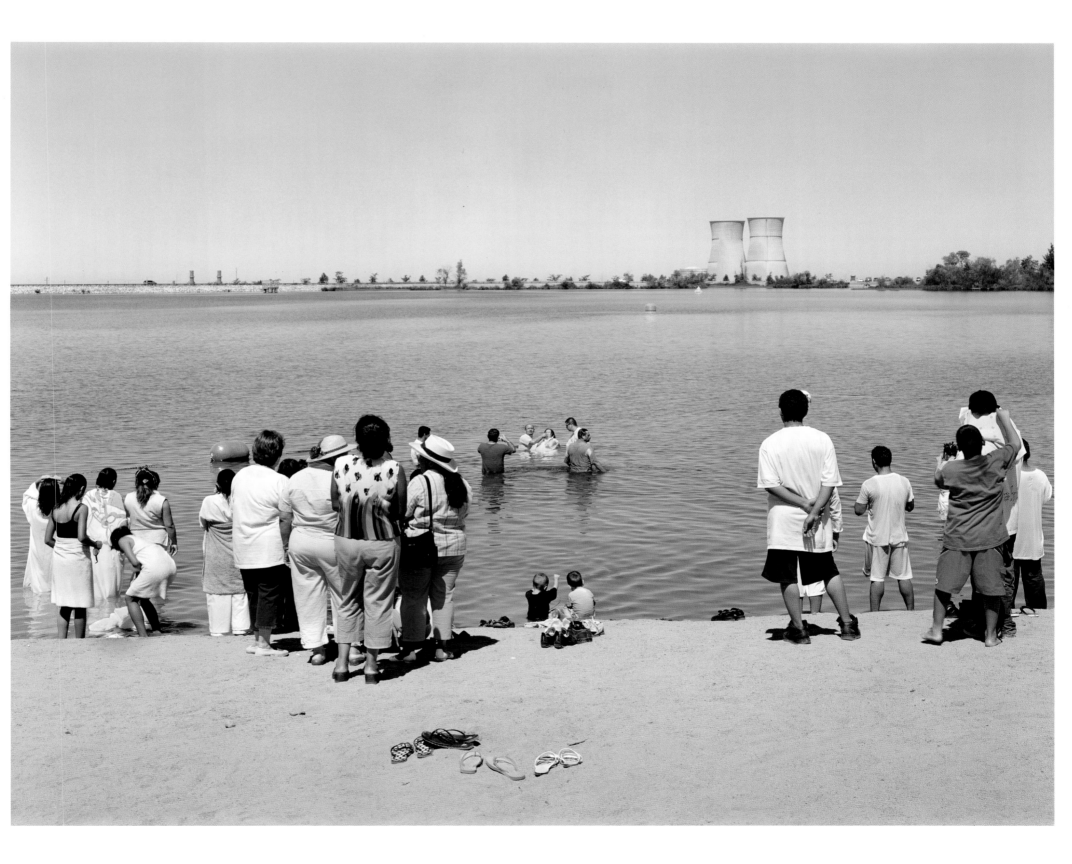

Big Bend Coal Power Station, Apollo Beach, Florida 2005

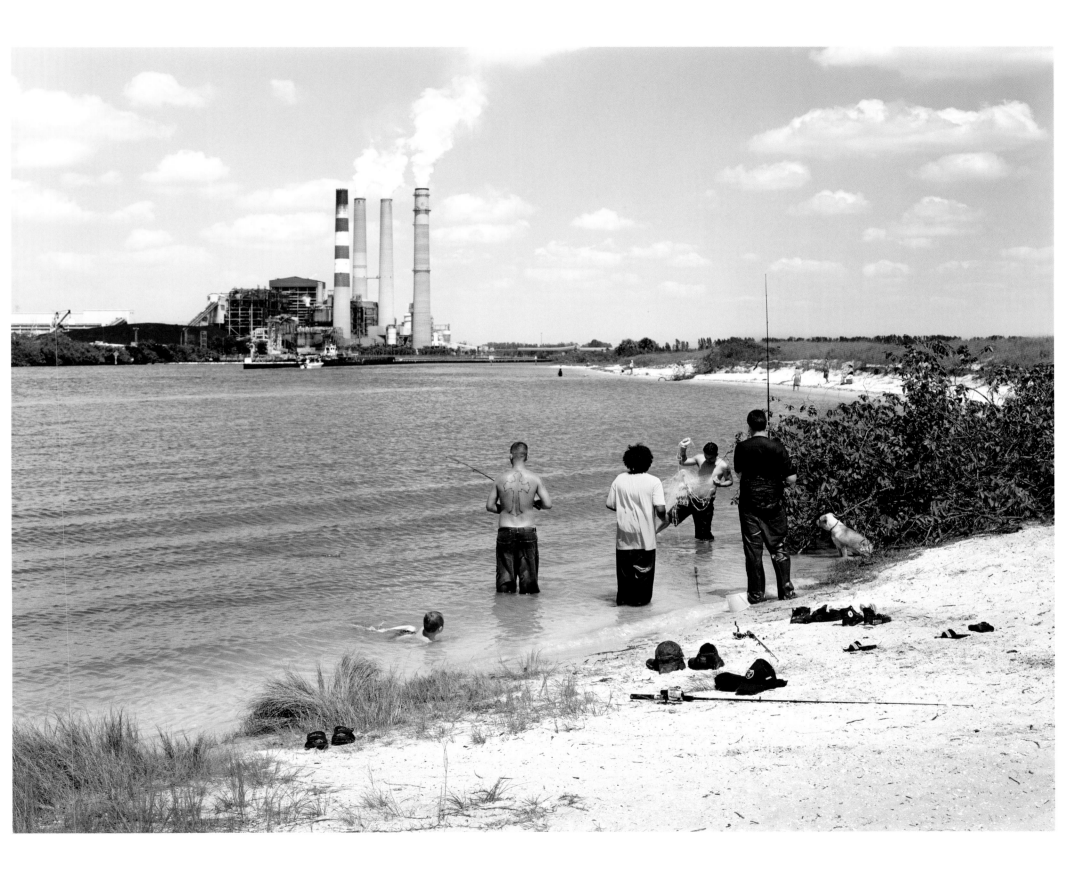

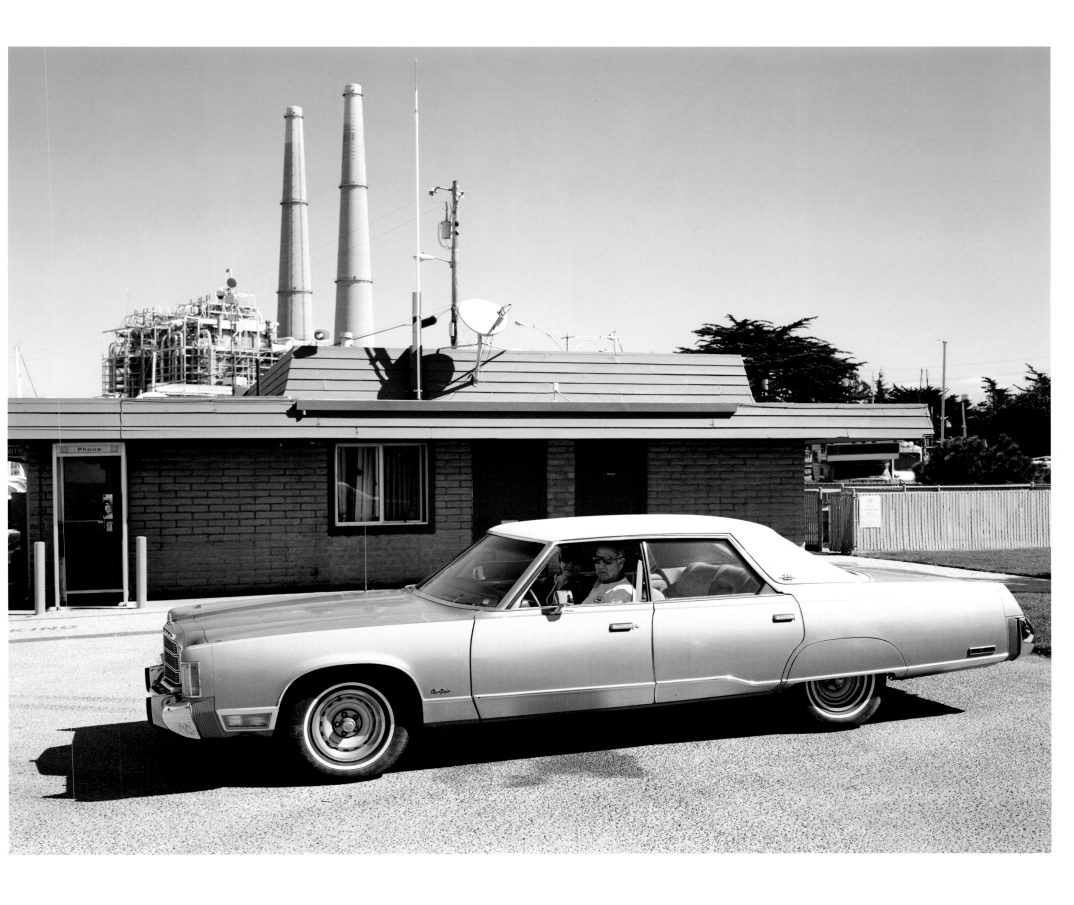

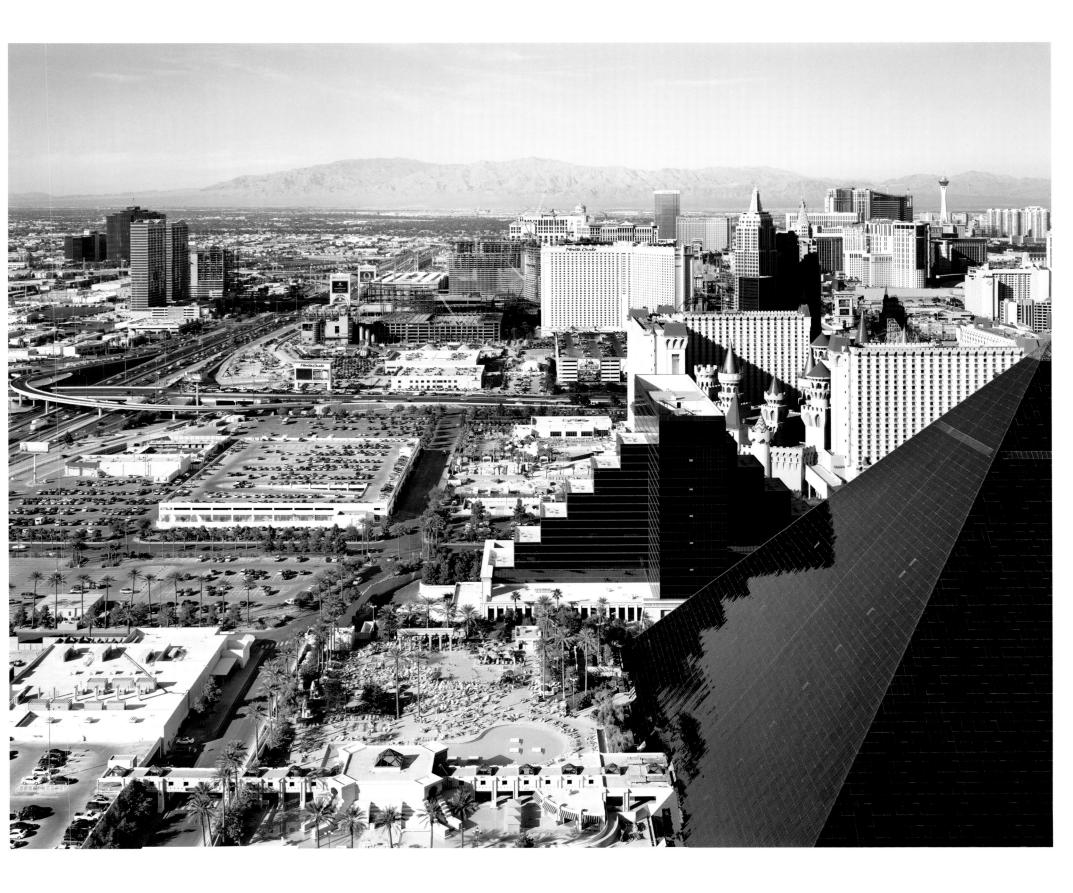

21 Yucca Mountain Nuclear Waste Repository, Nevada 2007

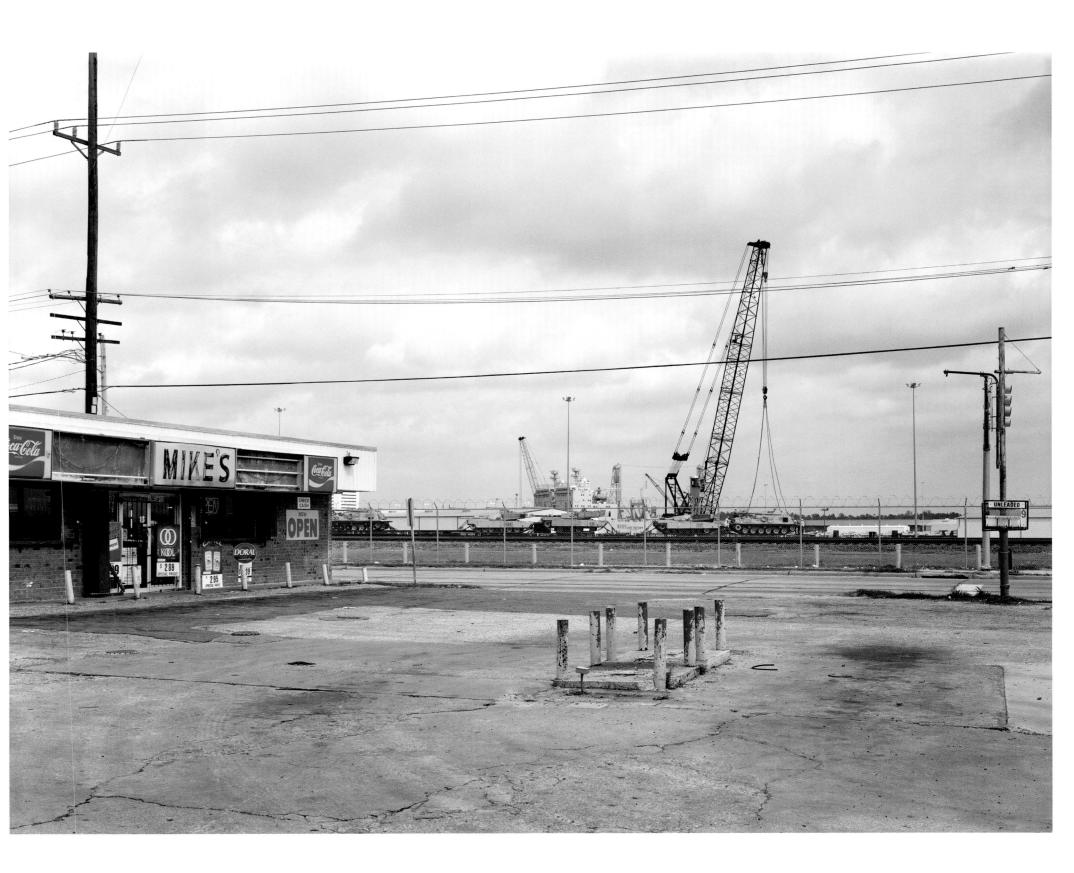

23 Fort Pierce, Florida 2005

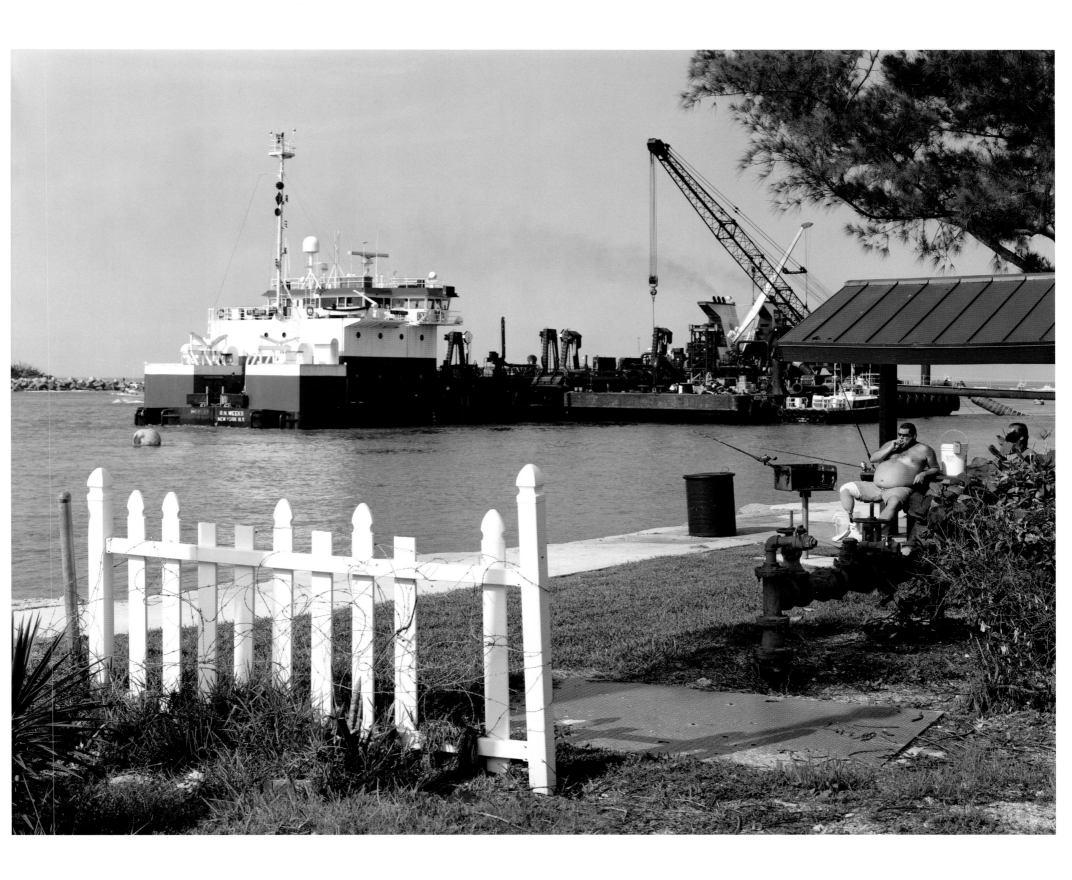

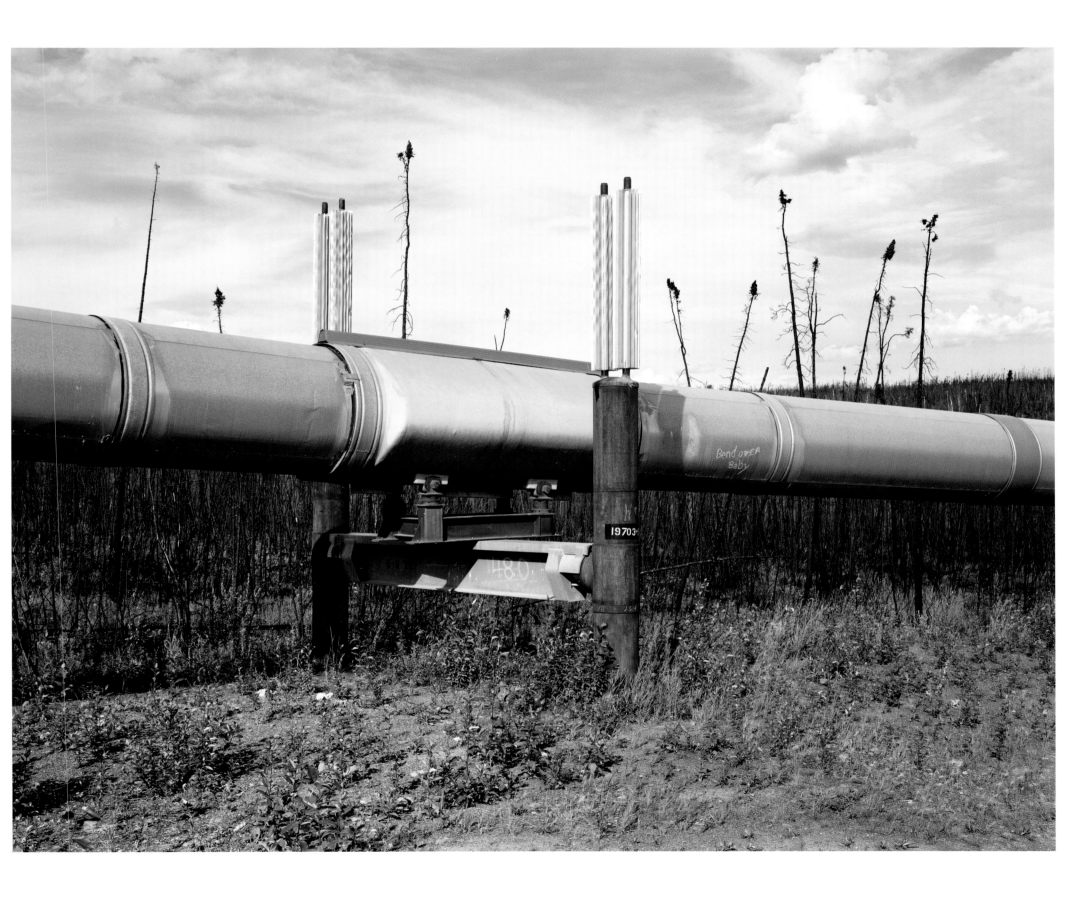

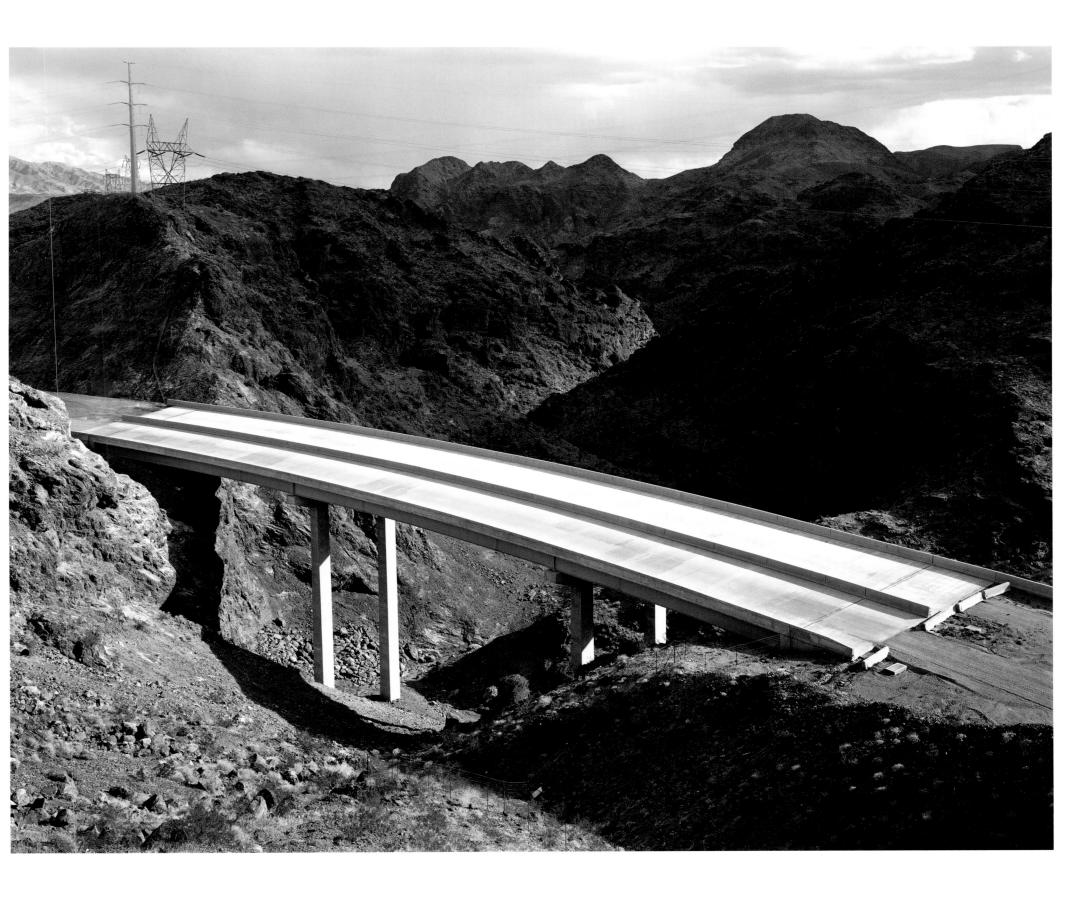

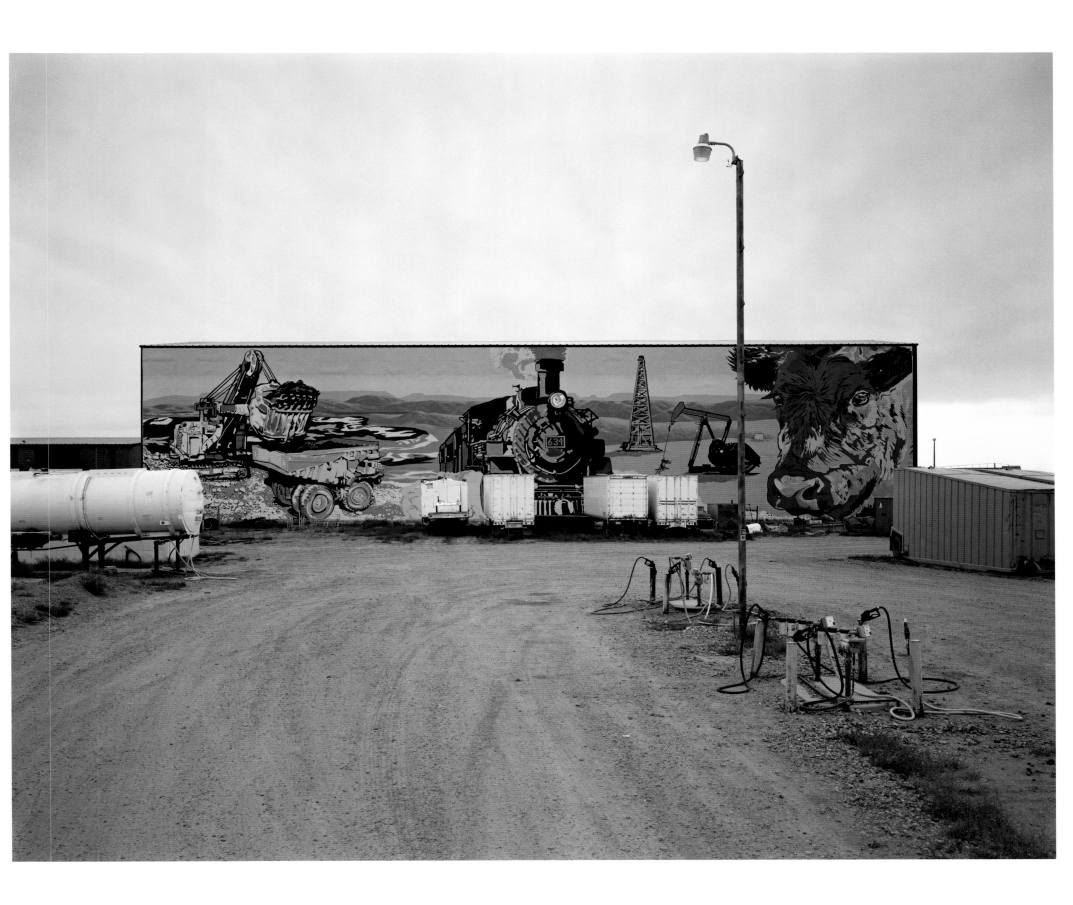

27 Ocean Warwick Oil Platform, Dauphine Island, Alabama 2005

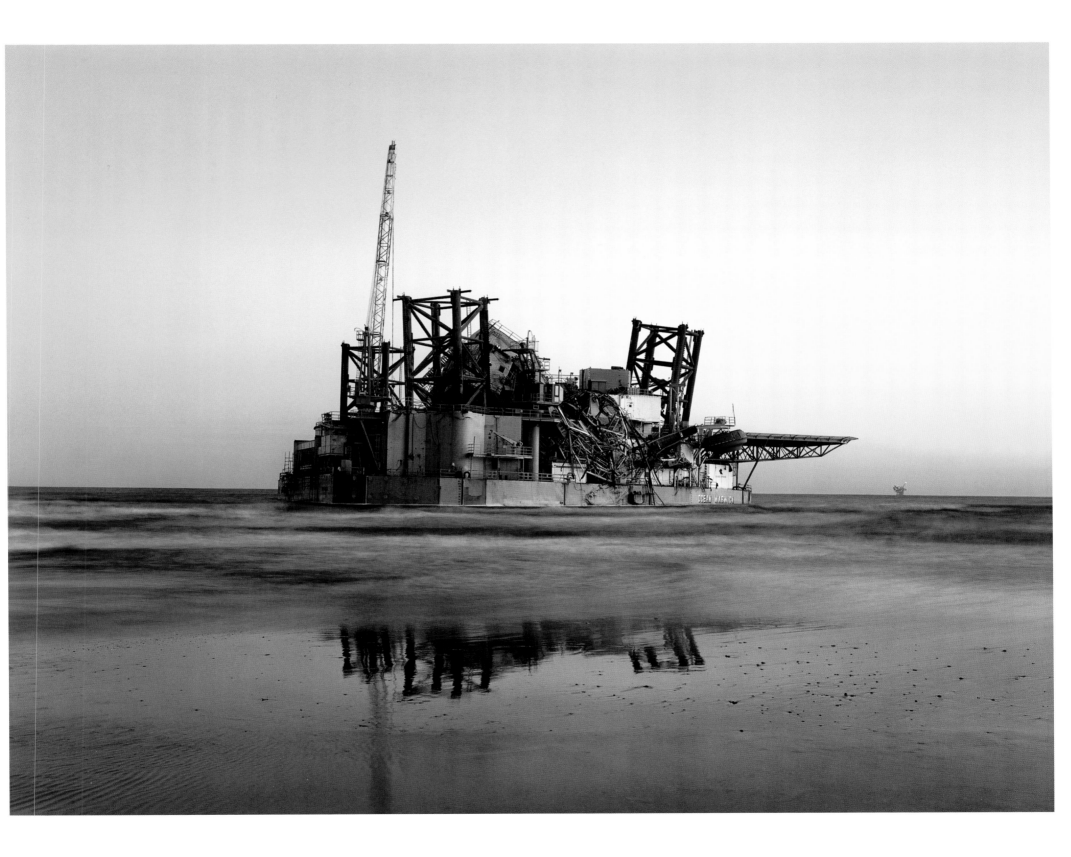

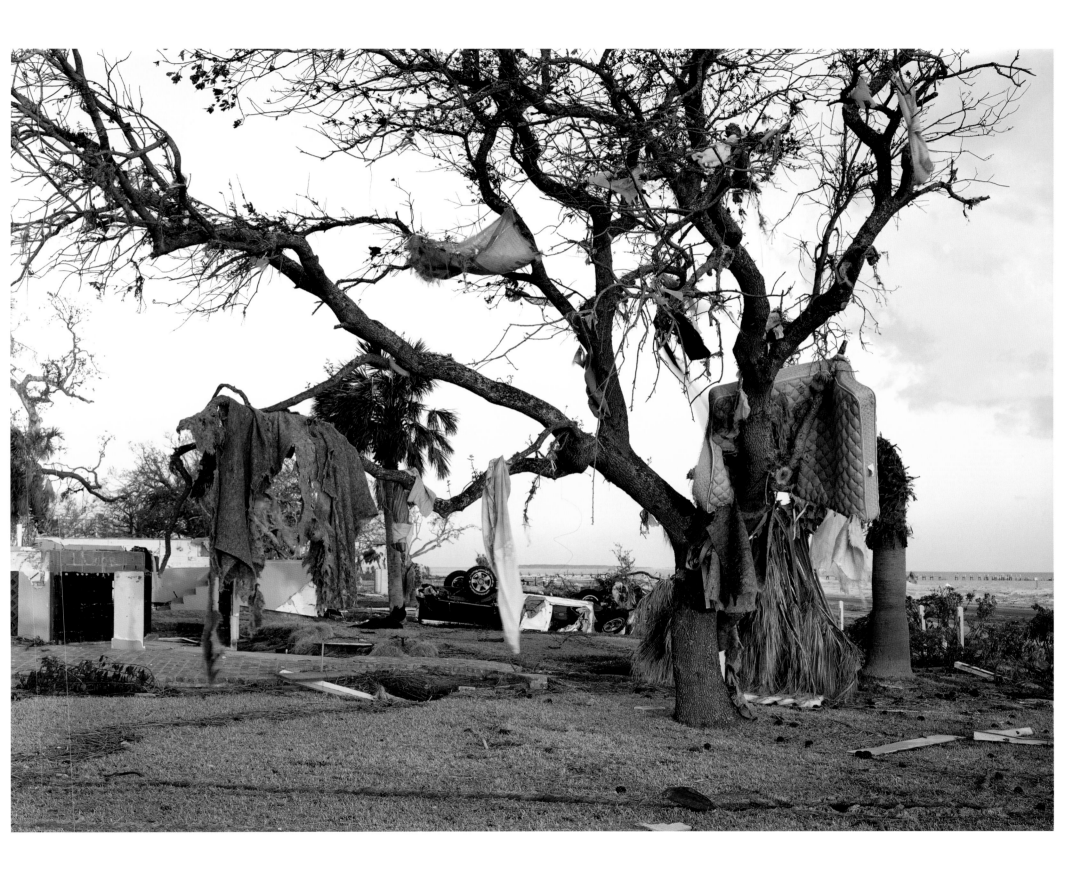

29 Martha Murphy and Charlie Biggs, Pass Christian, Mississippi 2005

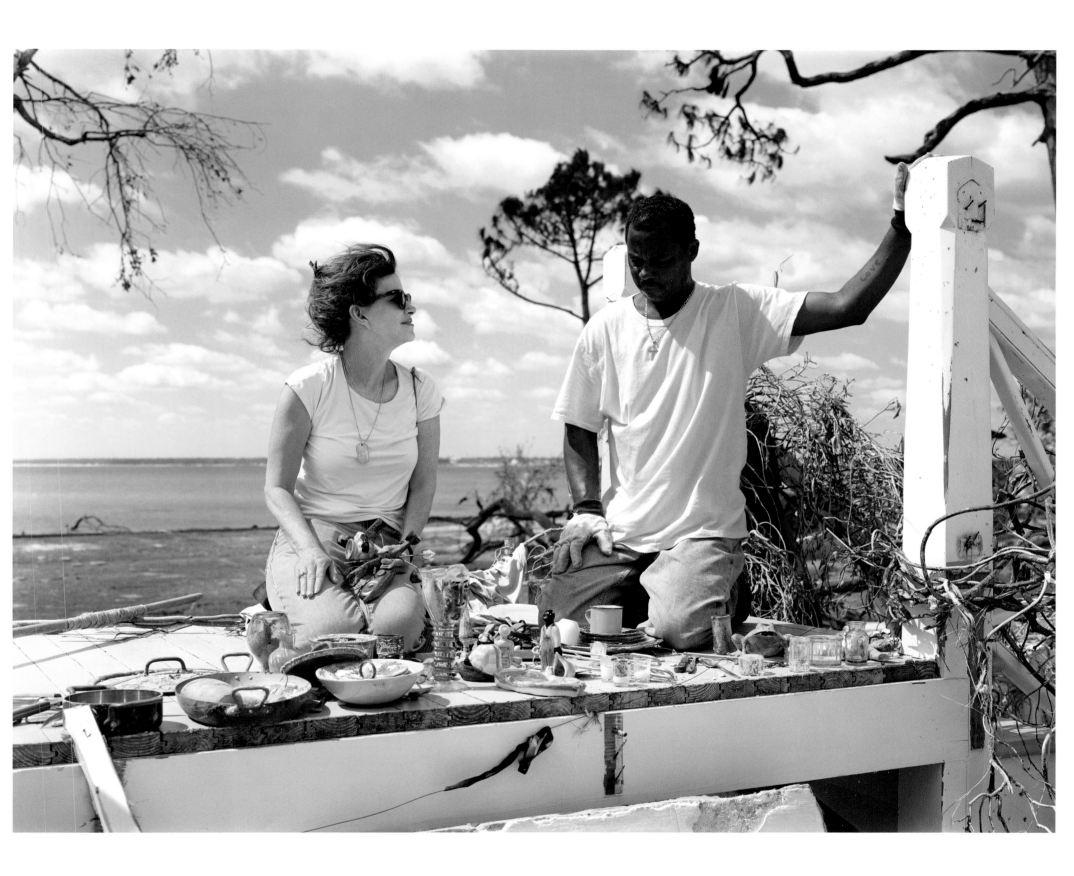

Academy of Holy Angels Convent, New Orleans, Louisiana 2005

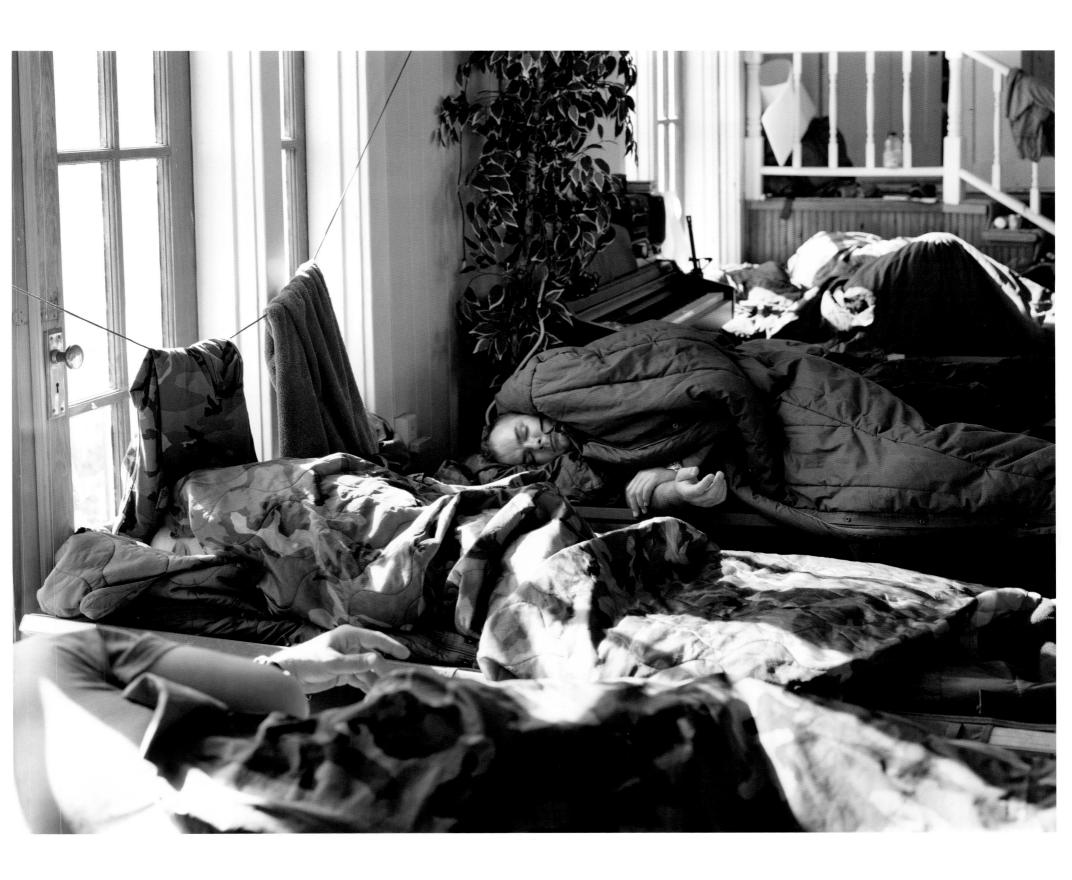

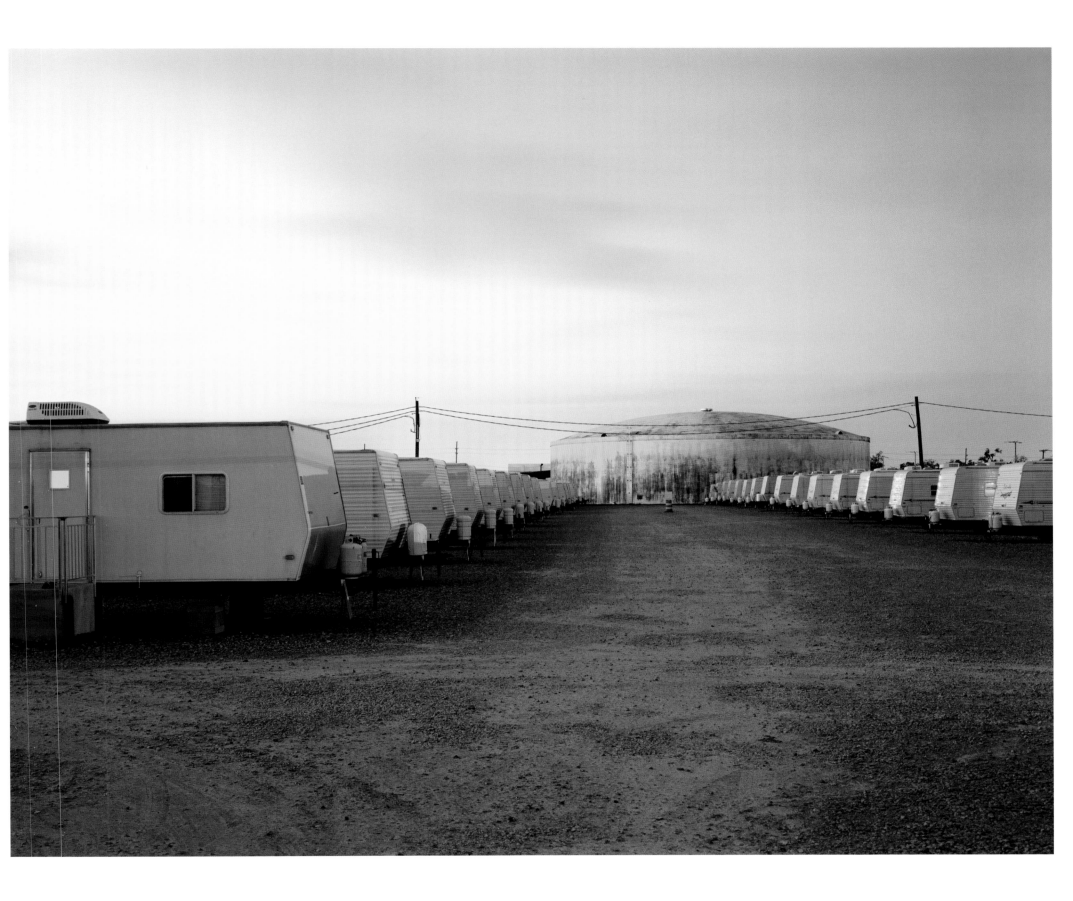

32 Louisiana Superdome, New Orleans 2005

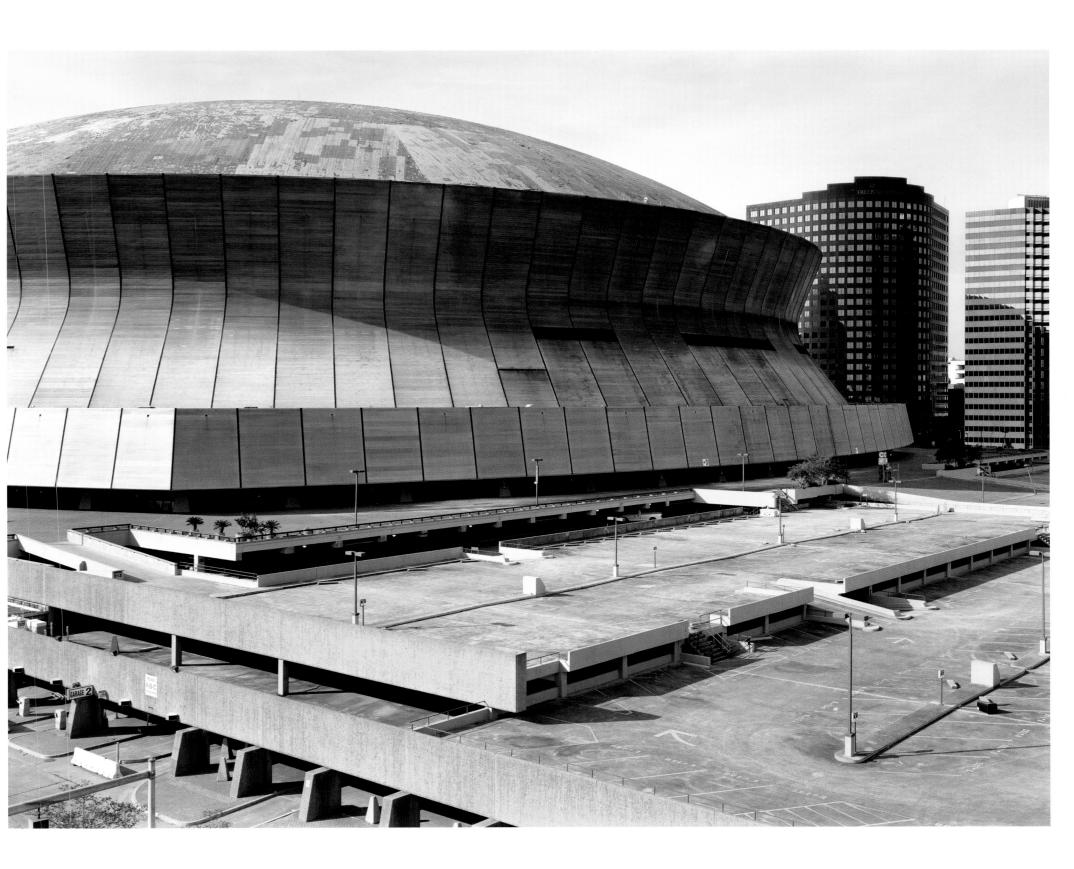

33 Grand Gulf Nuclear Regulatory Office, Mississippi 2006

36 Hoover Dam and Lake Mead, Nevada/Arizona 2007

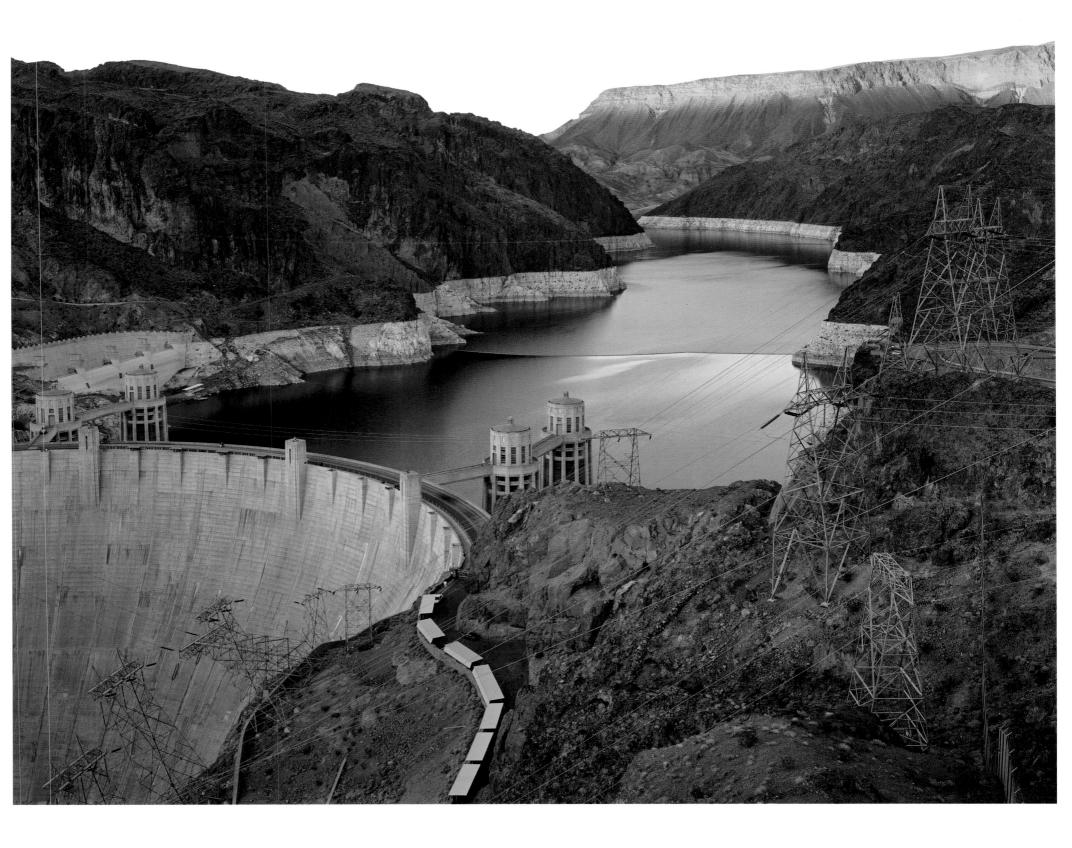

37　　Exit Glacier, Kenai Fjords National Park, Alaska 2007

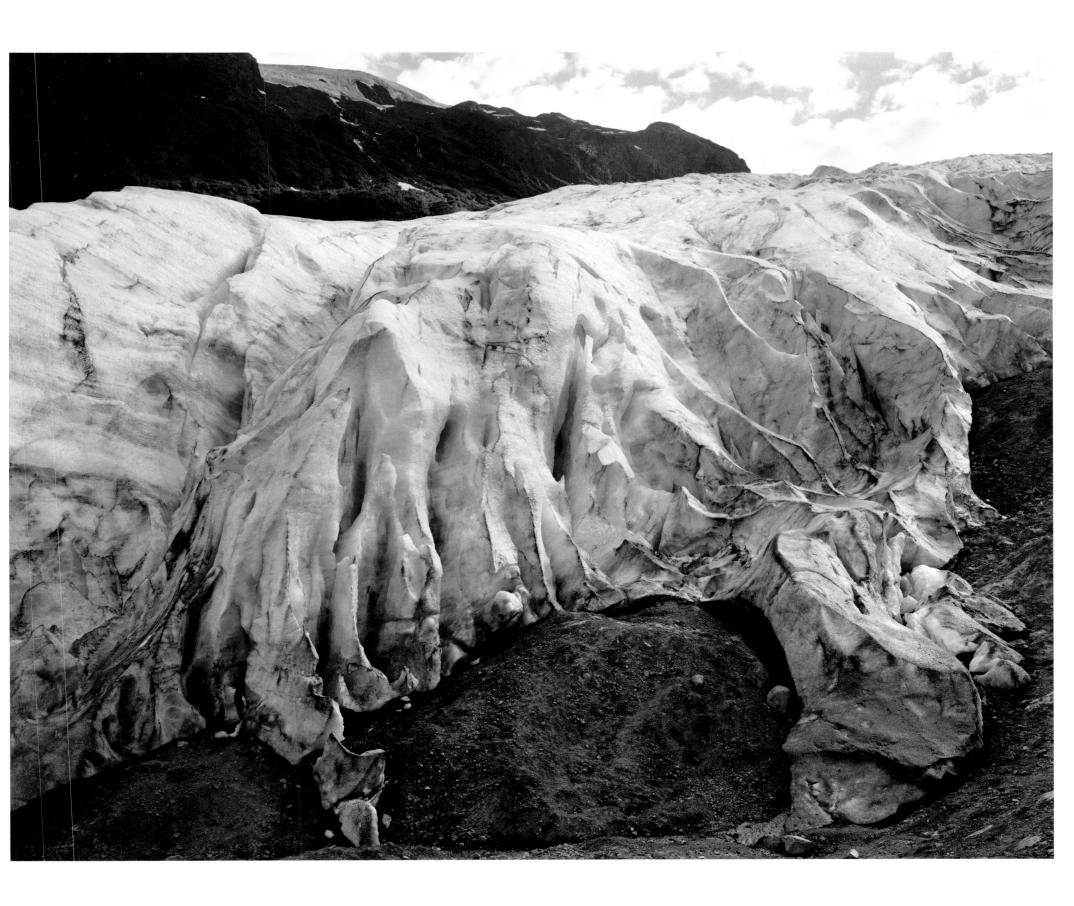

Chevron Oil Refinery, Point Richmond, California 2005

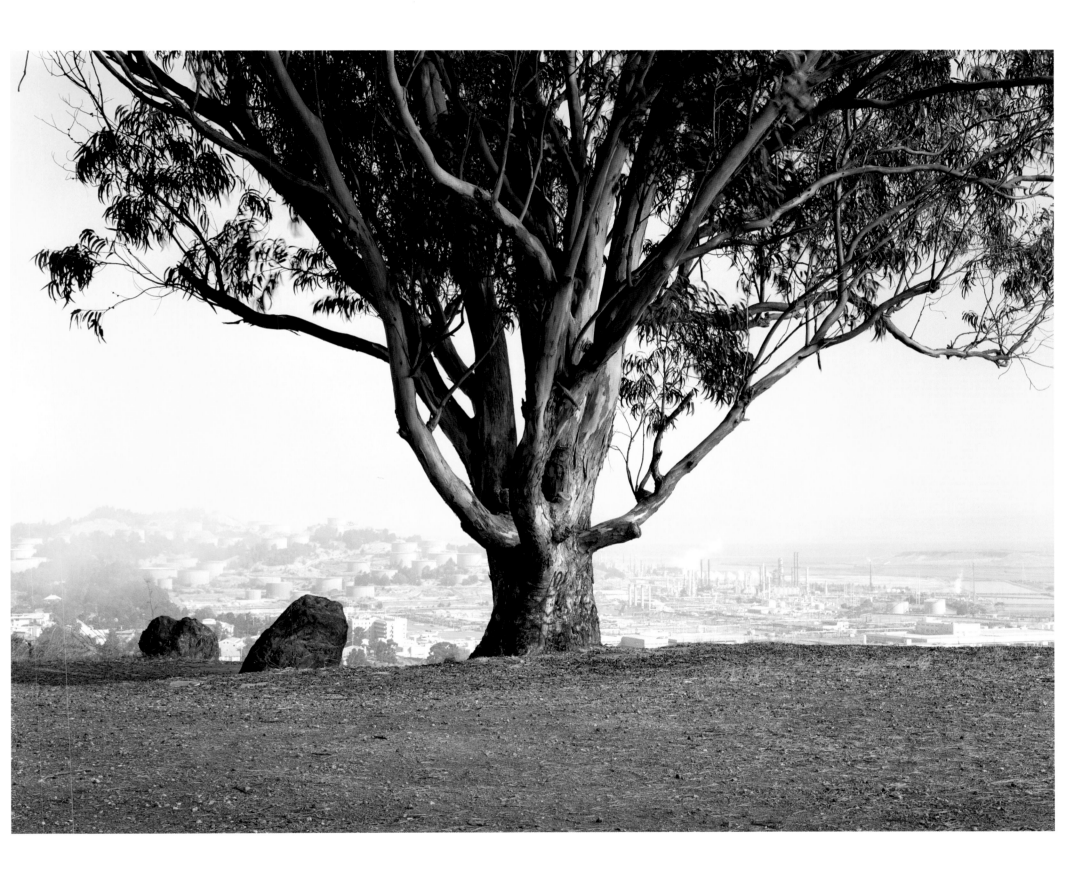

39 Kern River Oil Field, Oildale, California 2007

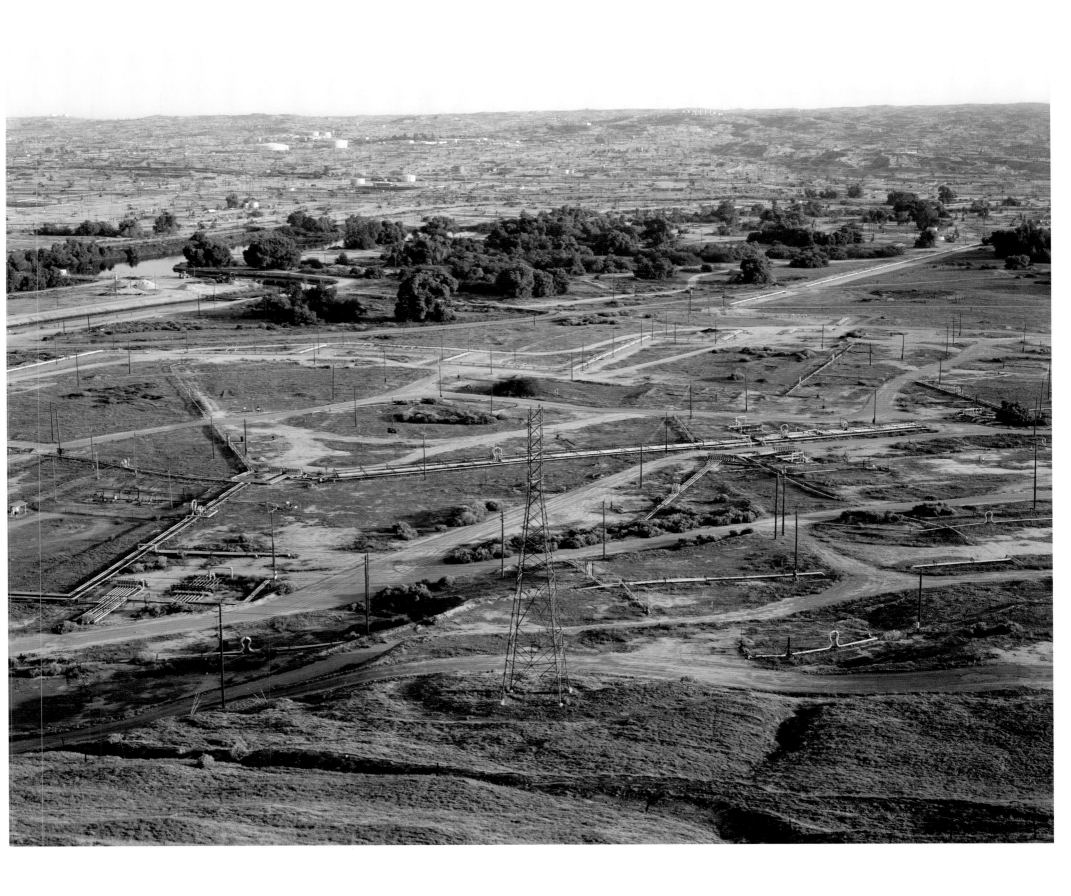

Iowa 80 Truckstop, Walcott, Iowa 2008

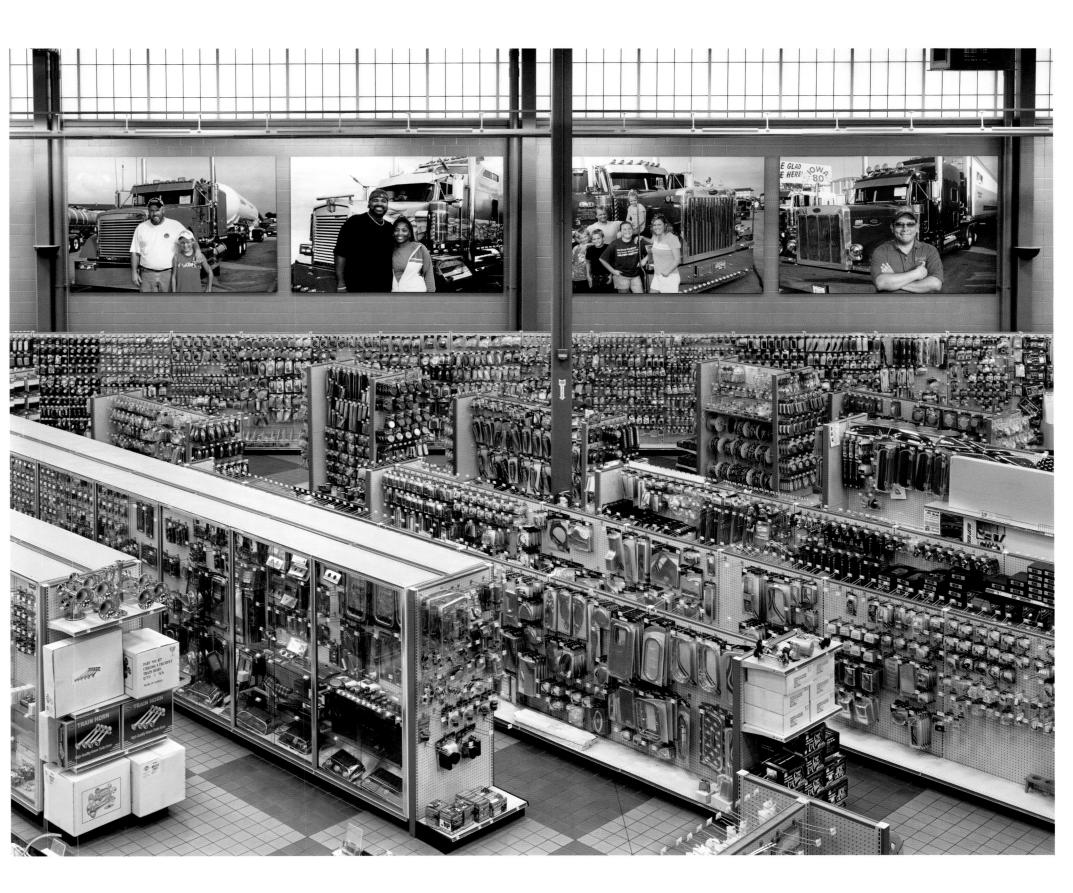

41 Conley Terminal, Boston, Massachusetts 2008

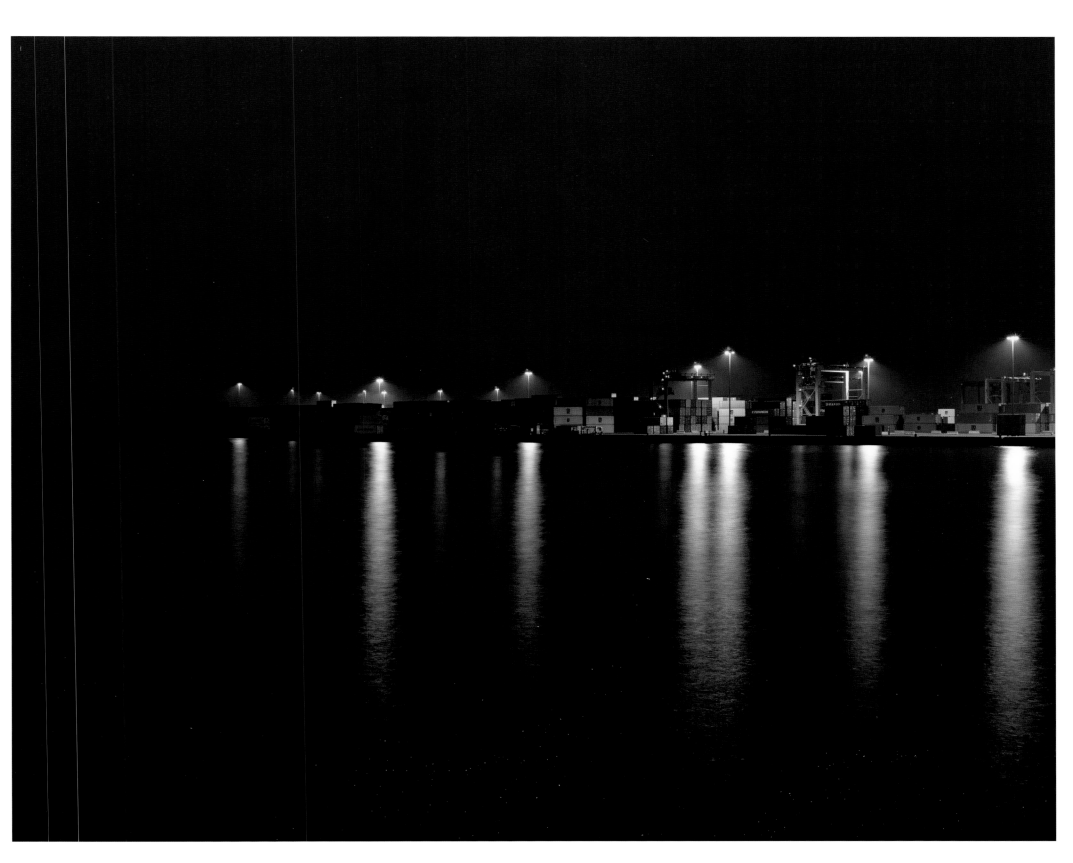

42 Green Mountain Wind Farm, Fluvana, Texas 2005

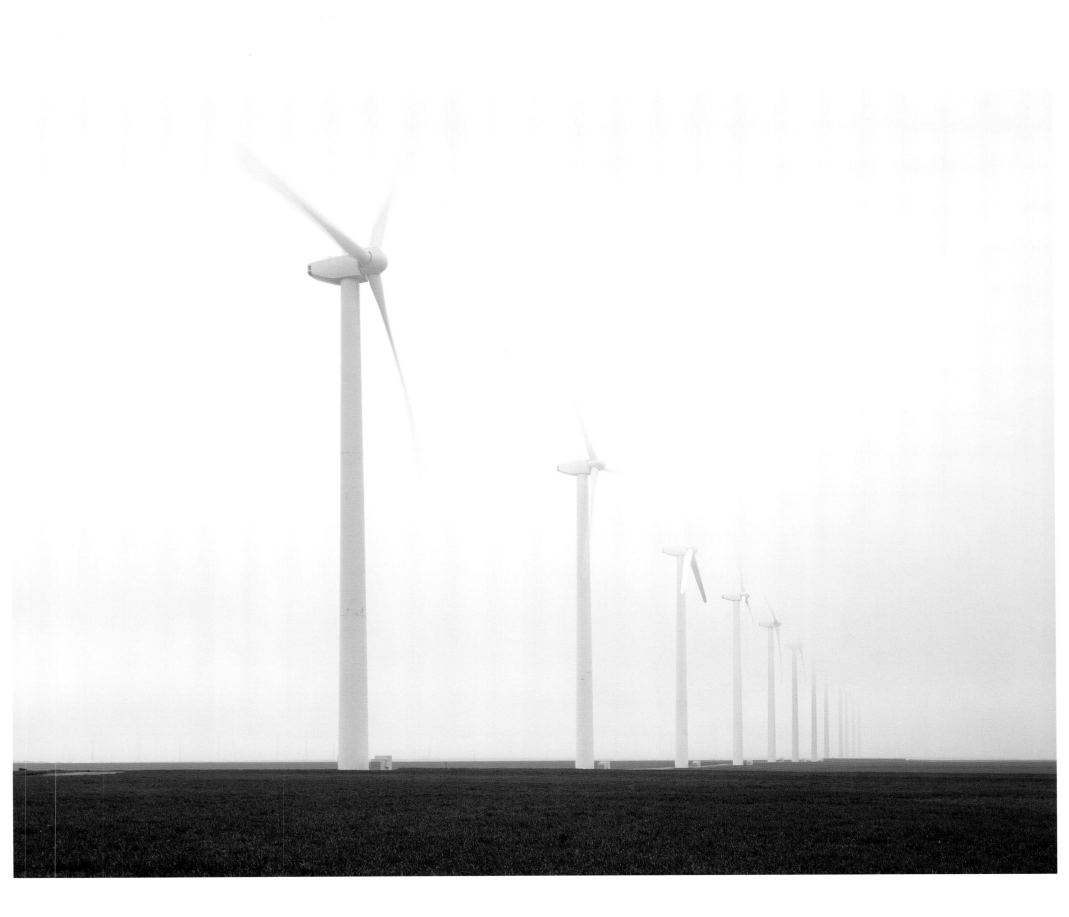

43 Chalmette Oil Refinery, New Orleans, Louisiana II 2007

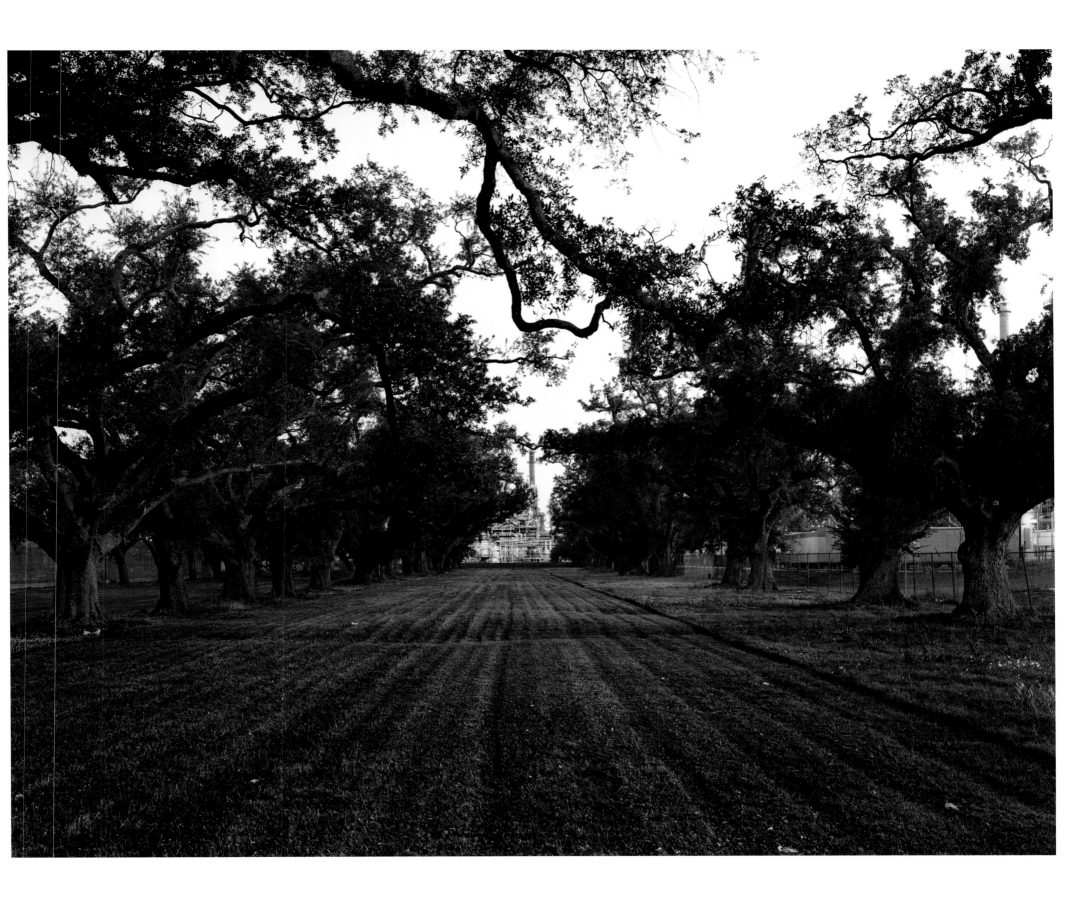

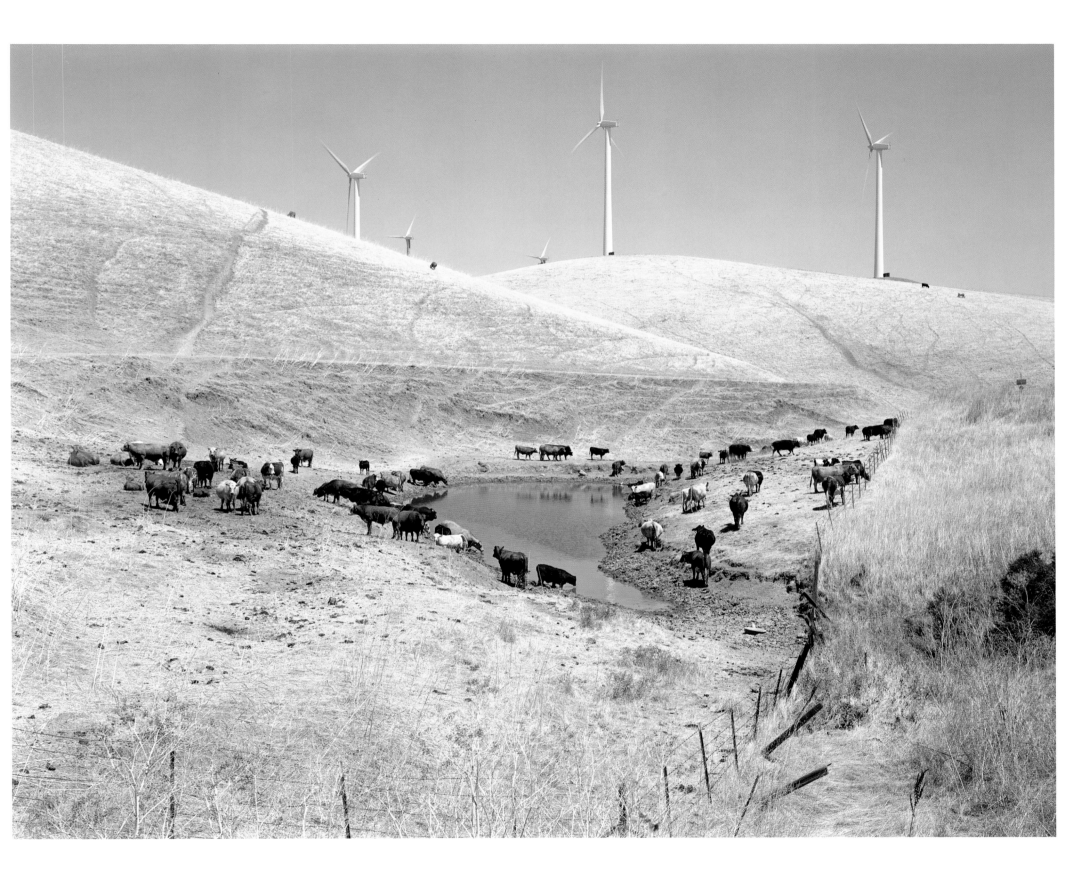

45 Freedom Mine, Beulah, North Dakota 2005

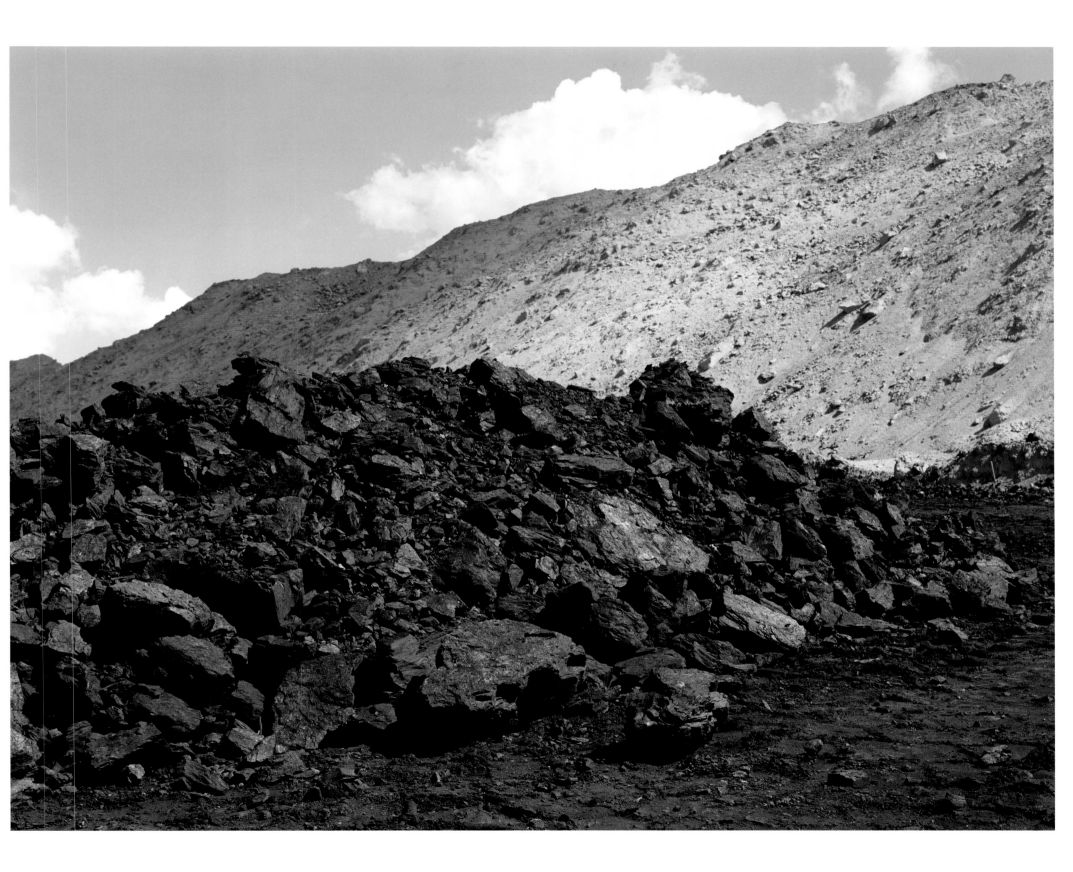

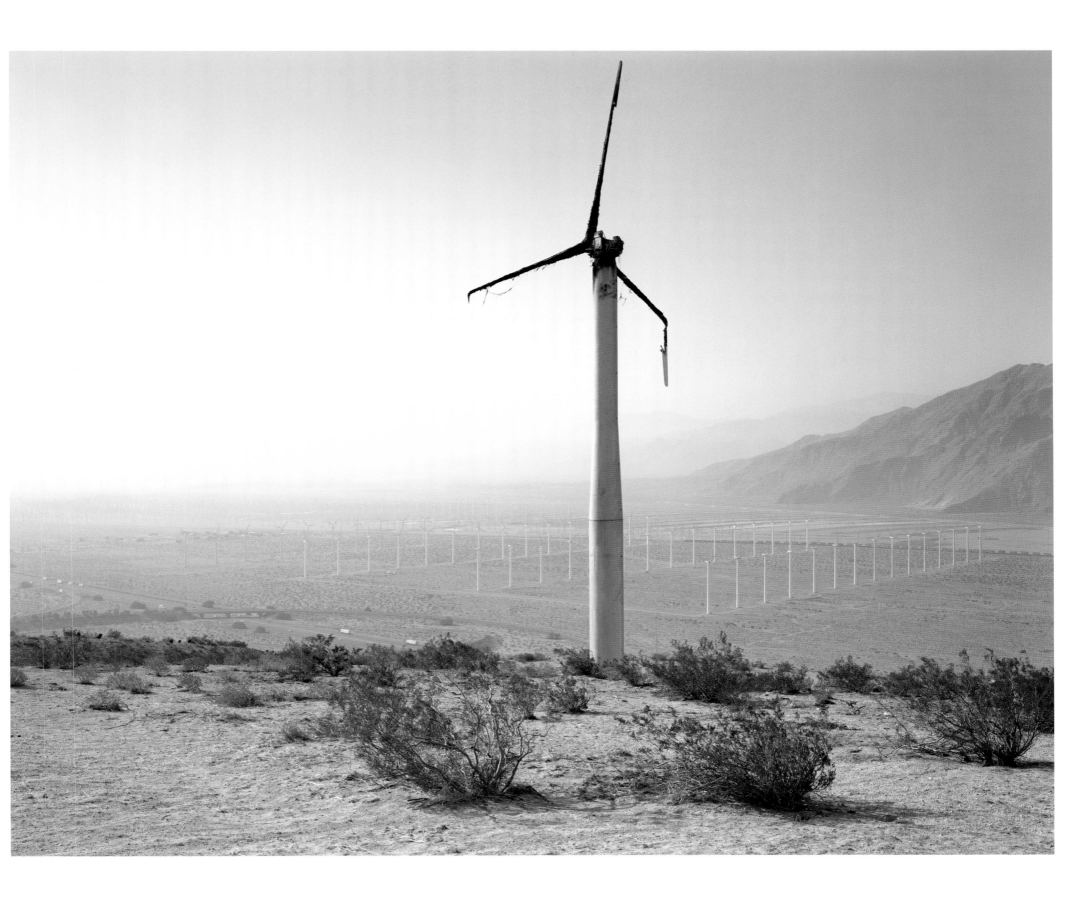

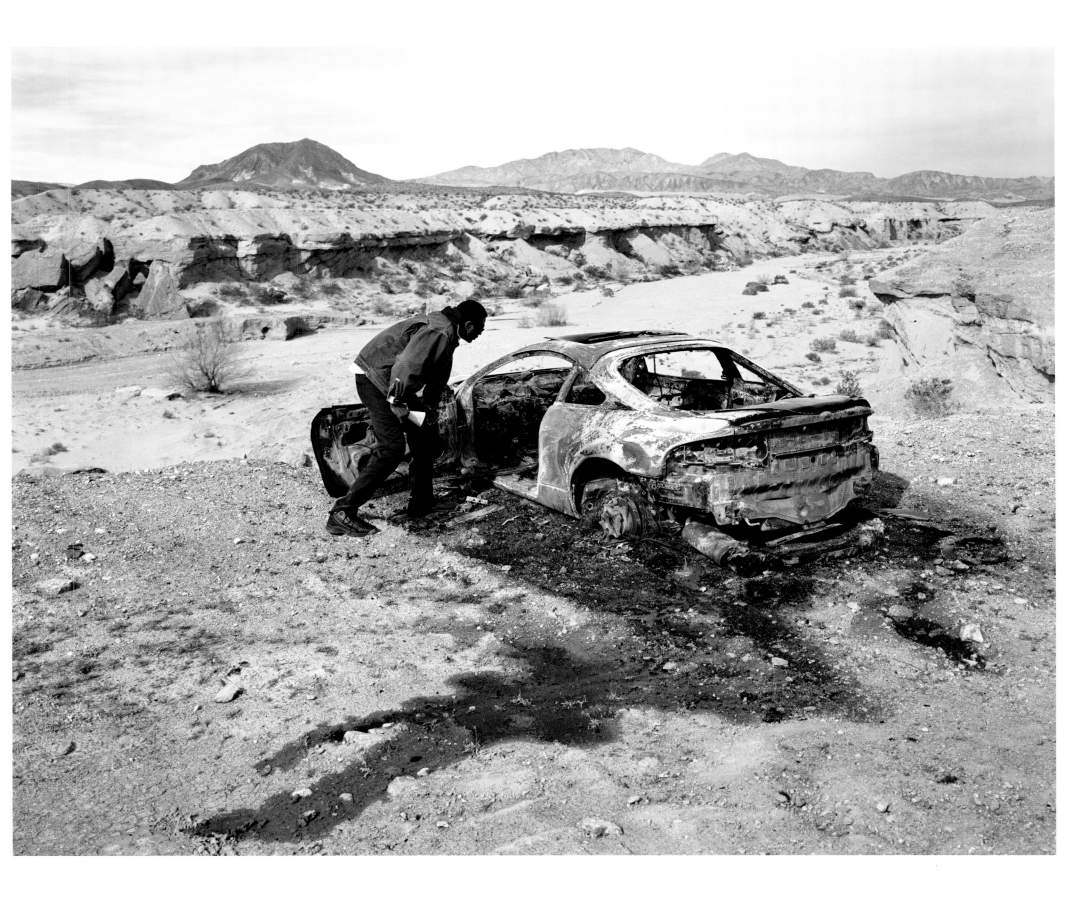

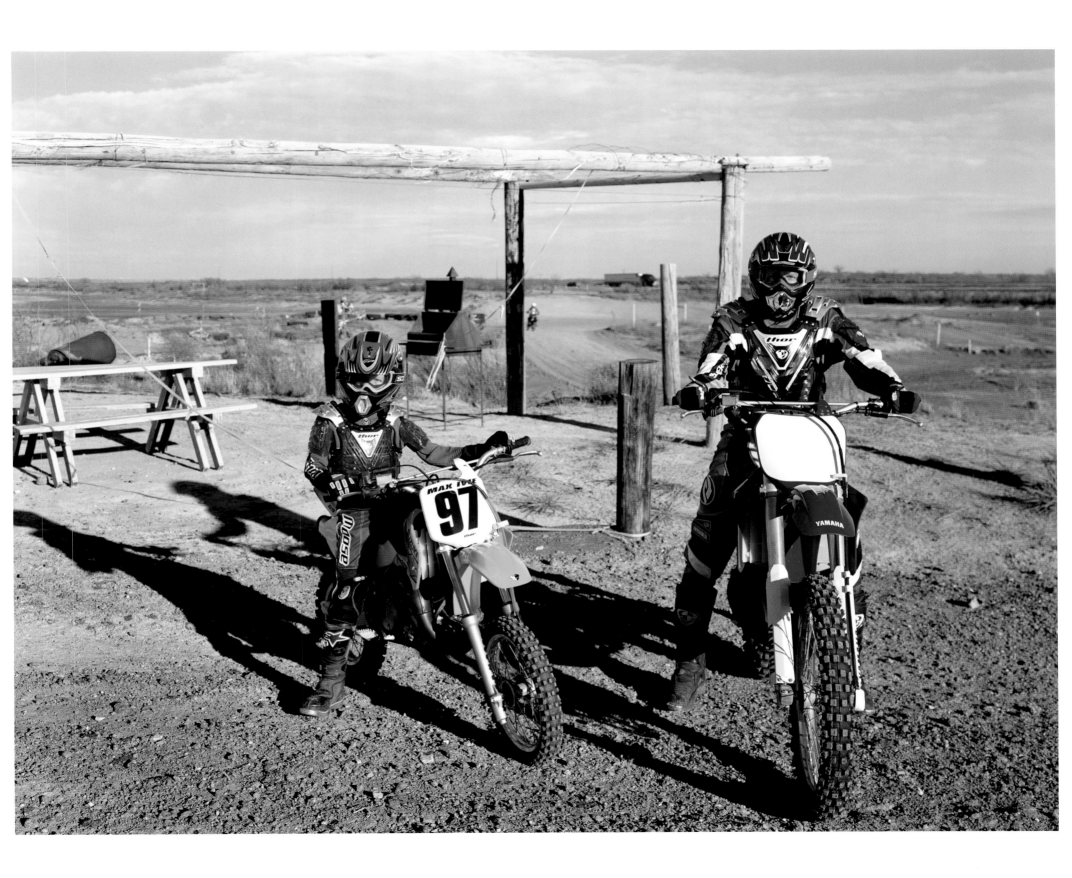

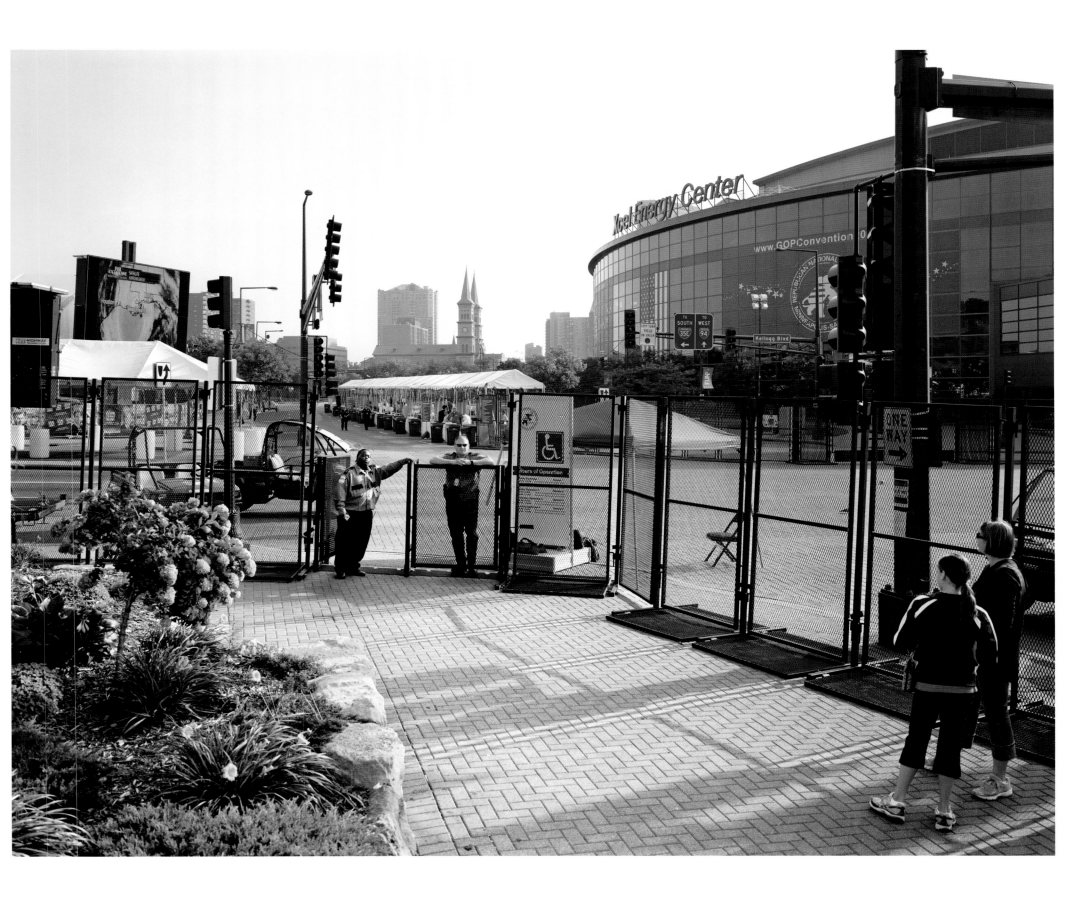

50 Solar Array, The Pentagon, Washington, D.C. 2008

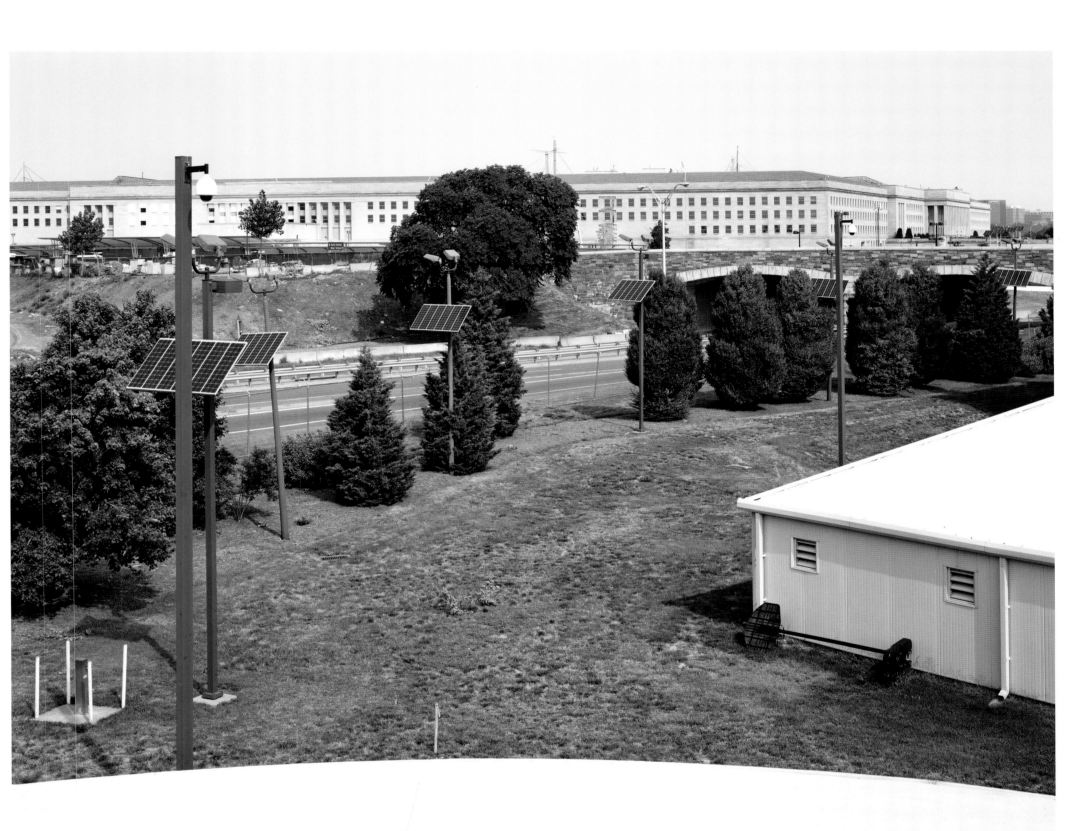

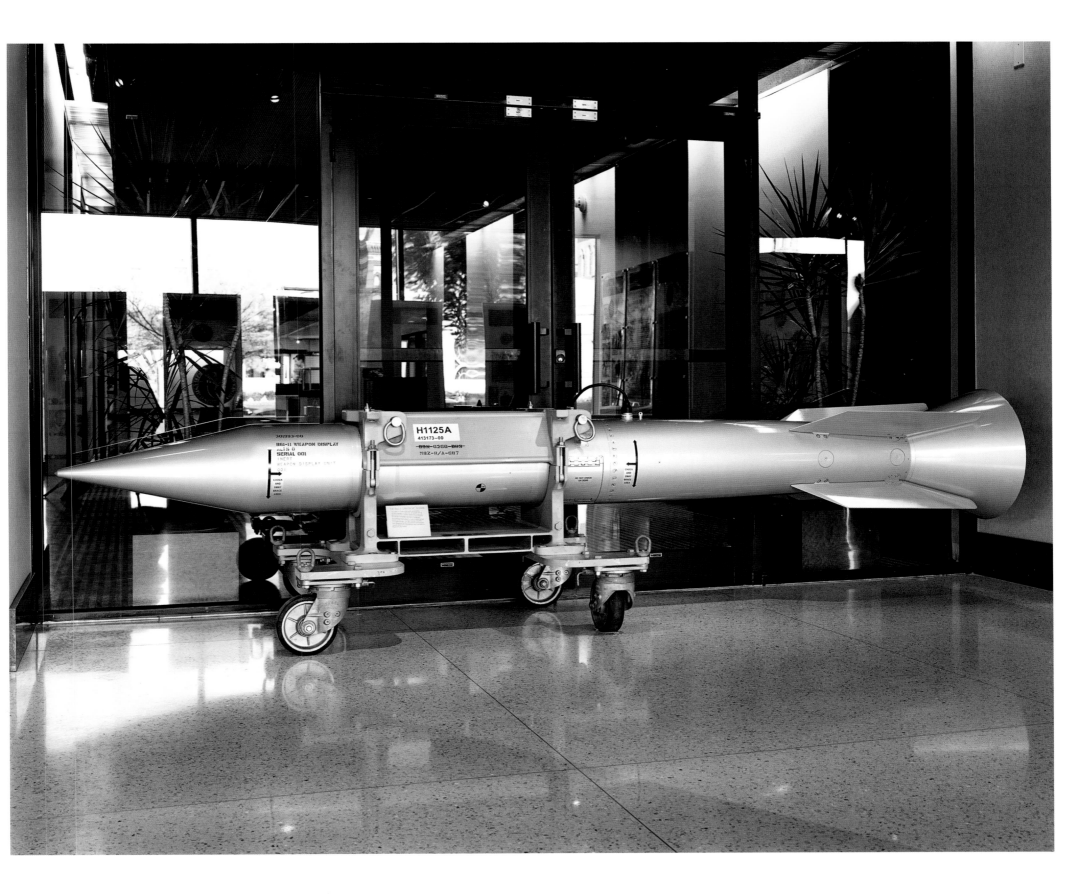

52 Trans-Alaska Pipeline, Alaska Range 2007

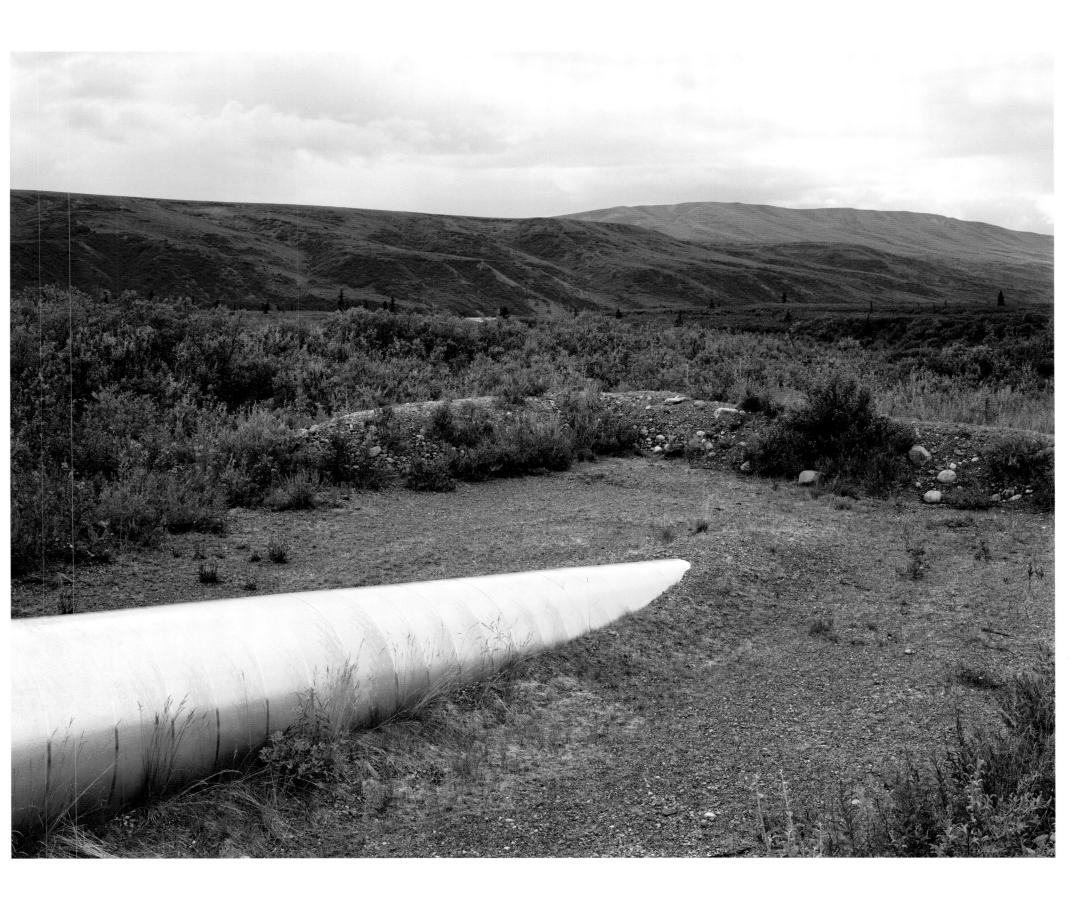

The Dalles Dam, Columbia River, Oregon 2006

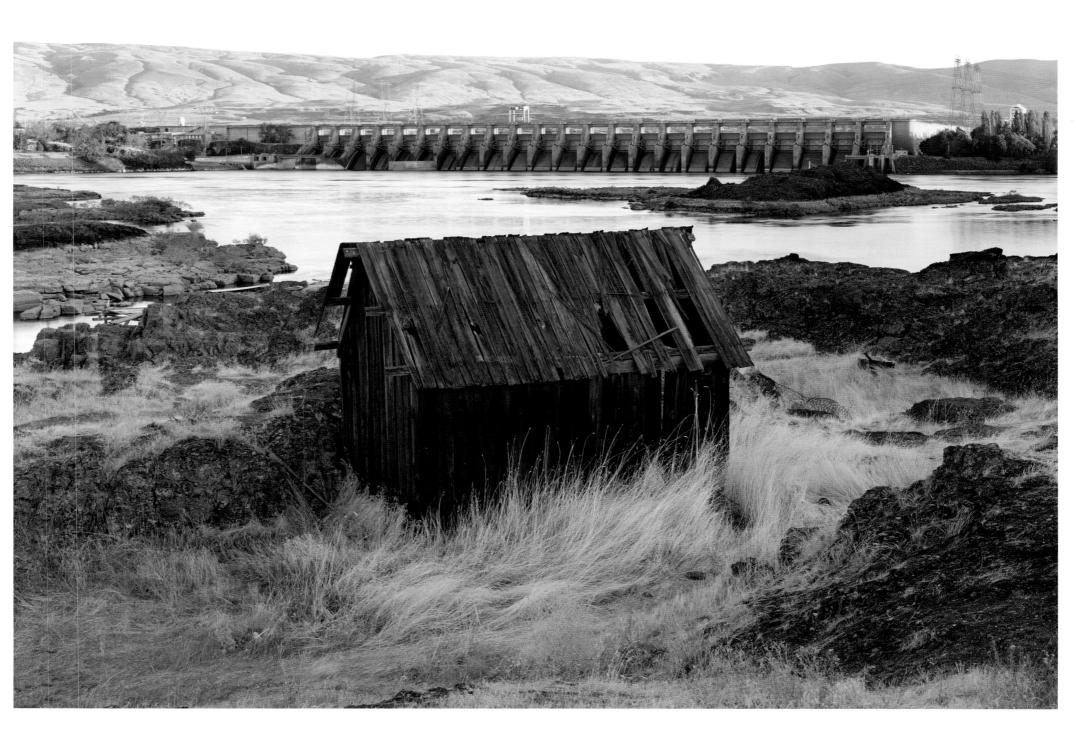

54 Solar Oven, Kawaihae, Hawaii 2008

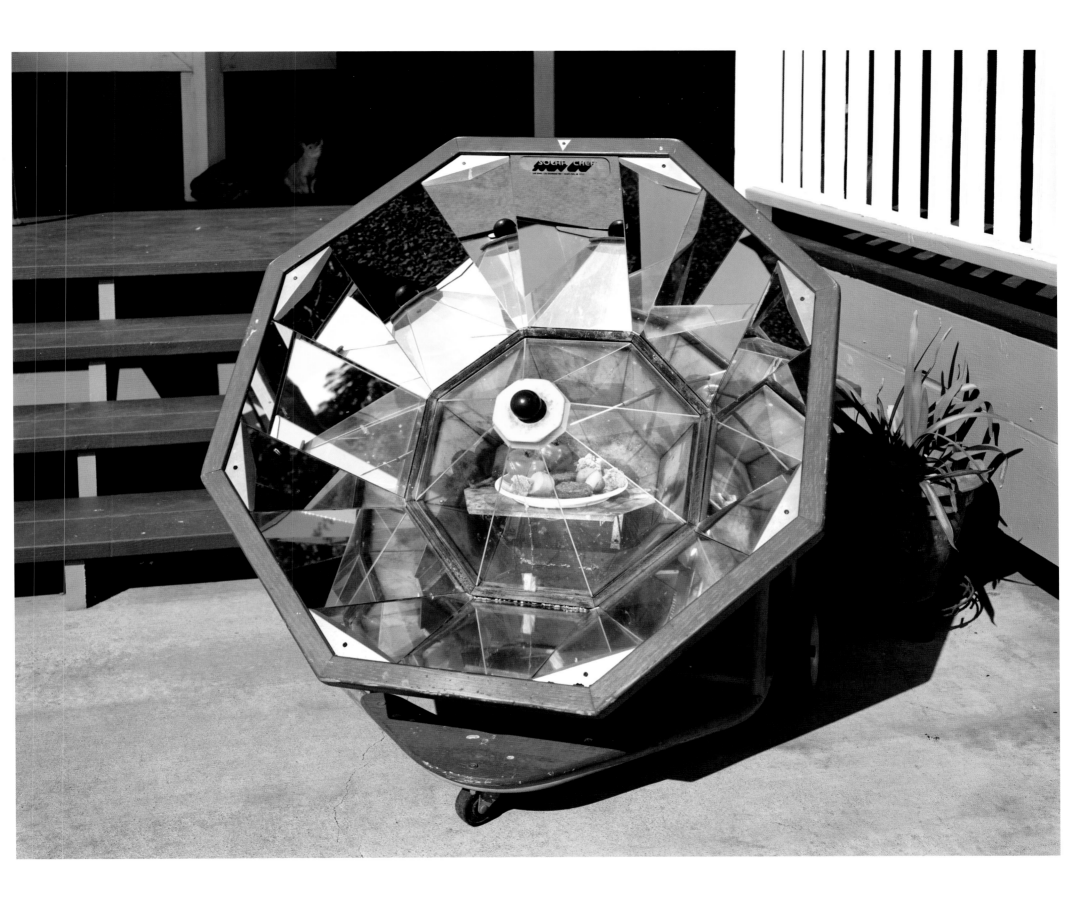

Fuel Cells, Bloom Energy Laboratory, Sunnyvale, California 2008

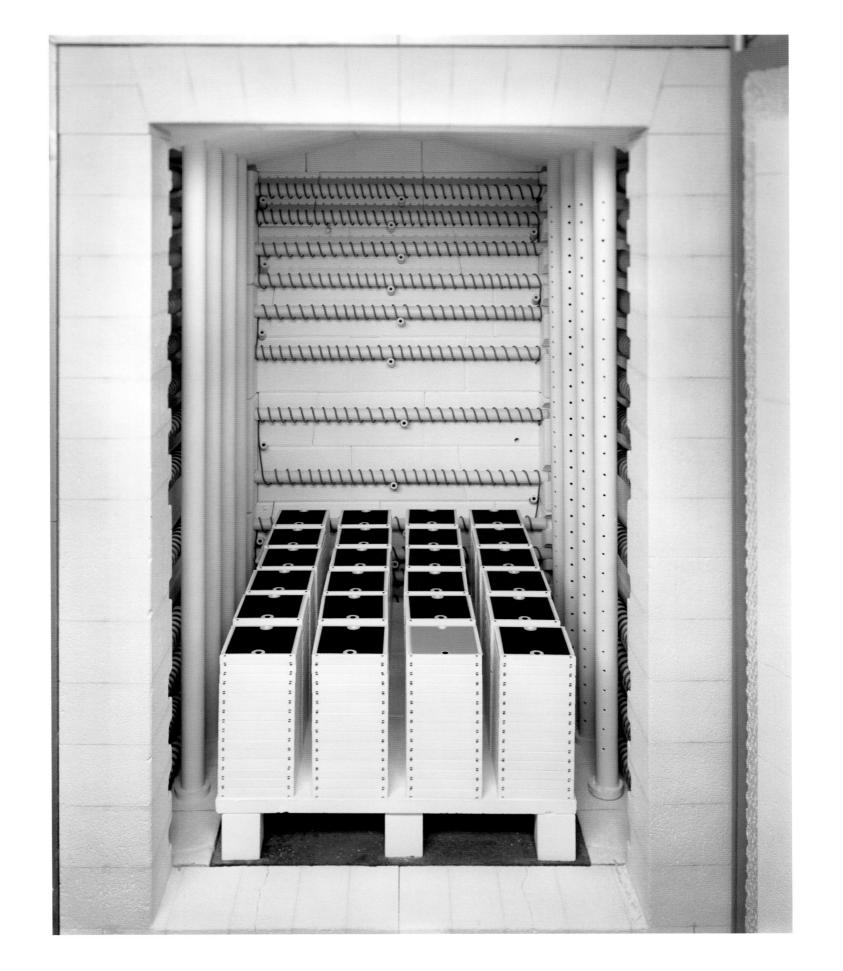

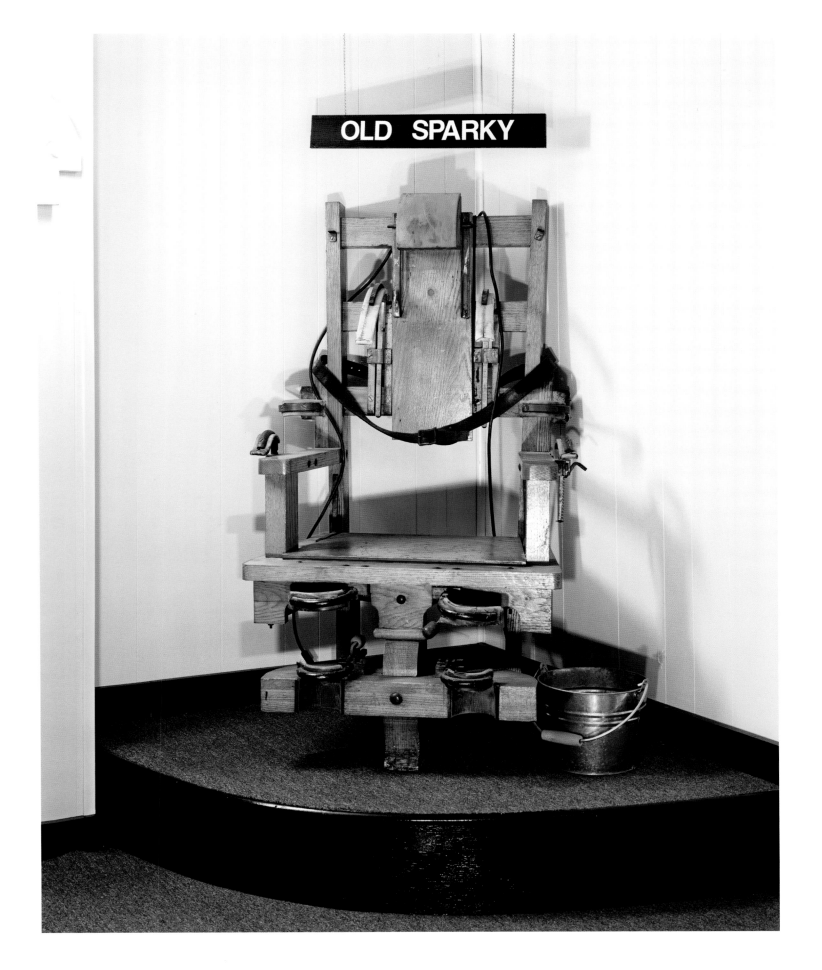

57 Chester Lowrey with Tesla Coil, Hawaii 2008

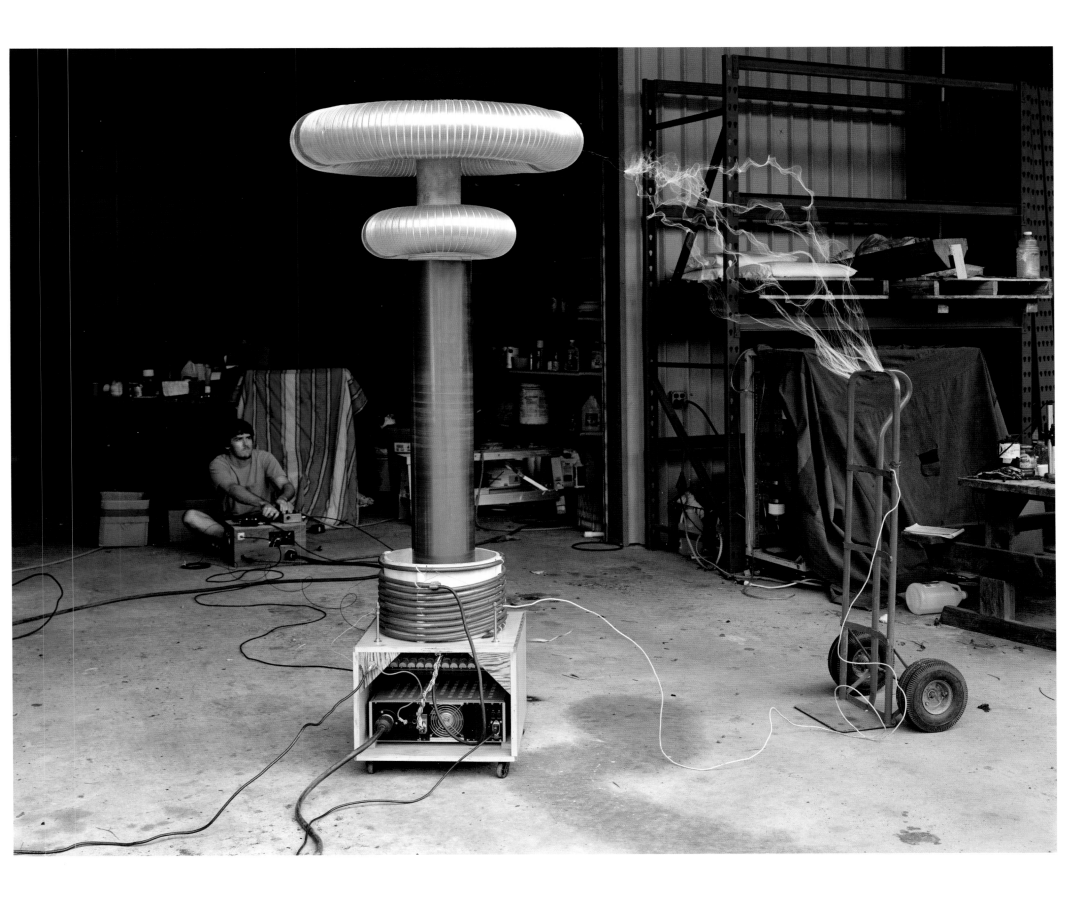

Solar Powered House, Kalapana, Hawaii 2008

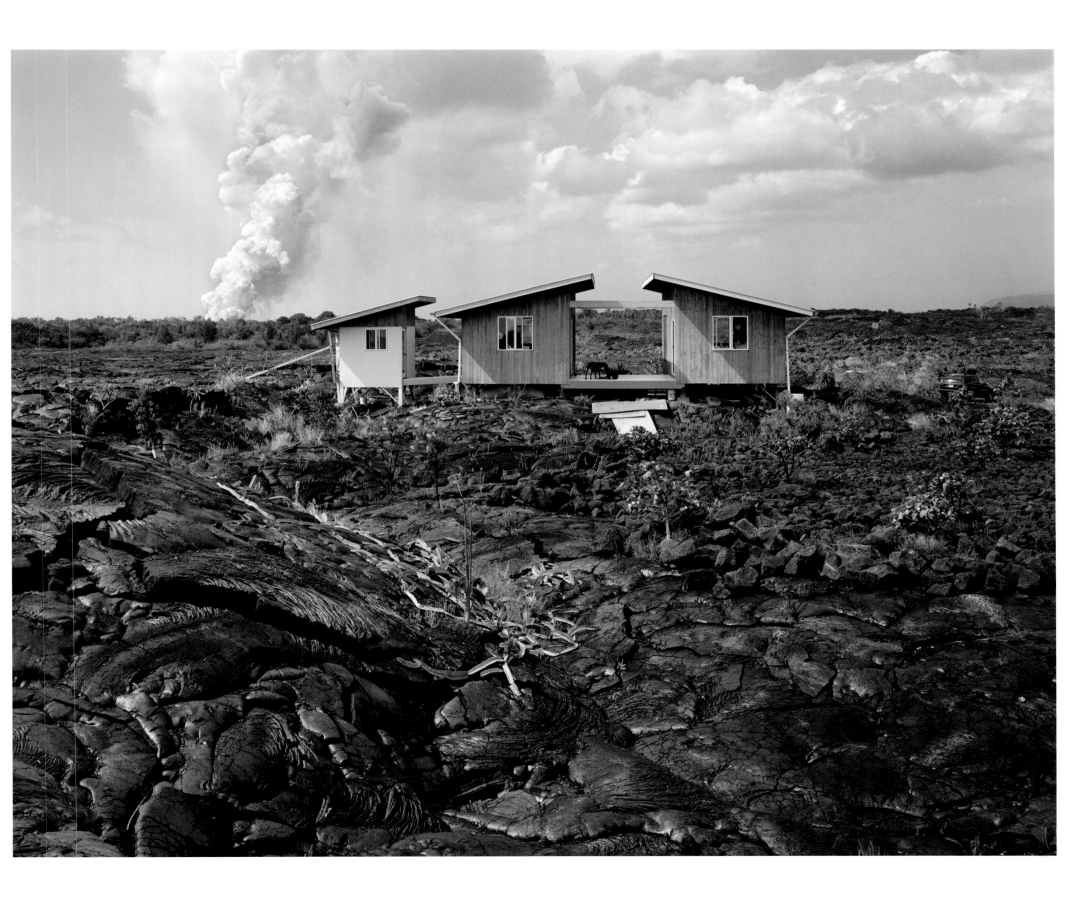

59 Trans-Alaska Pipeline Terminal, Valdez, Alaska 2007

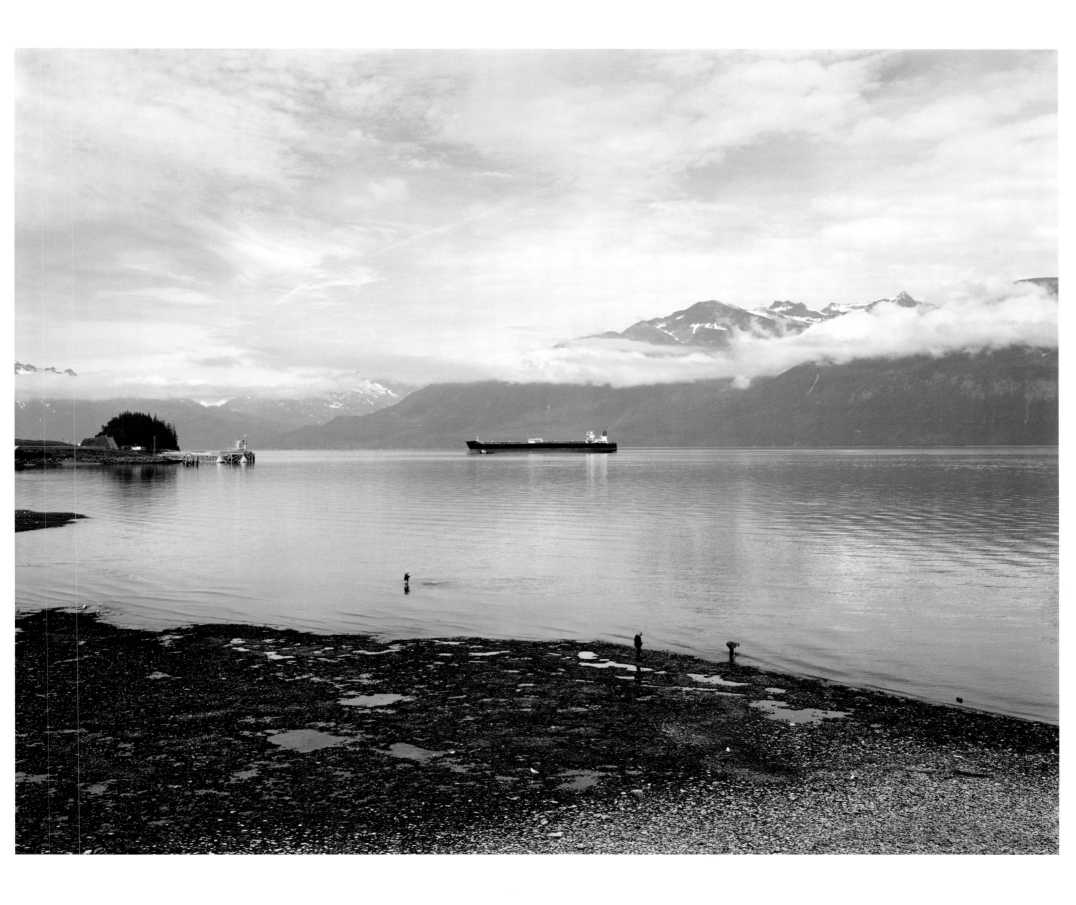

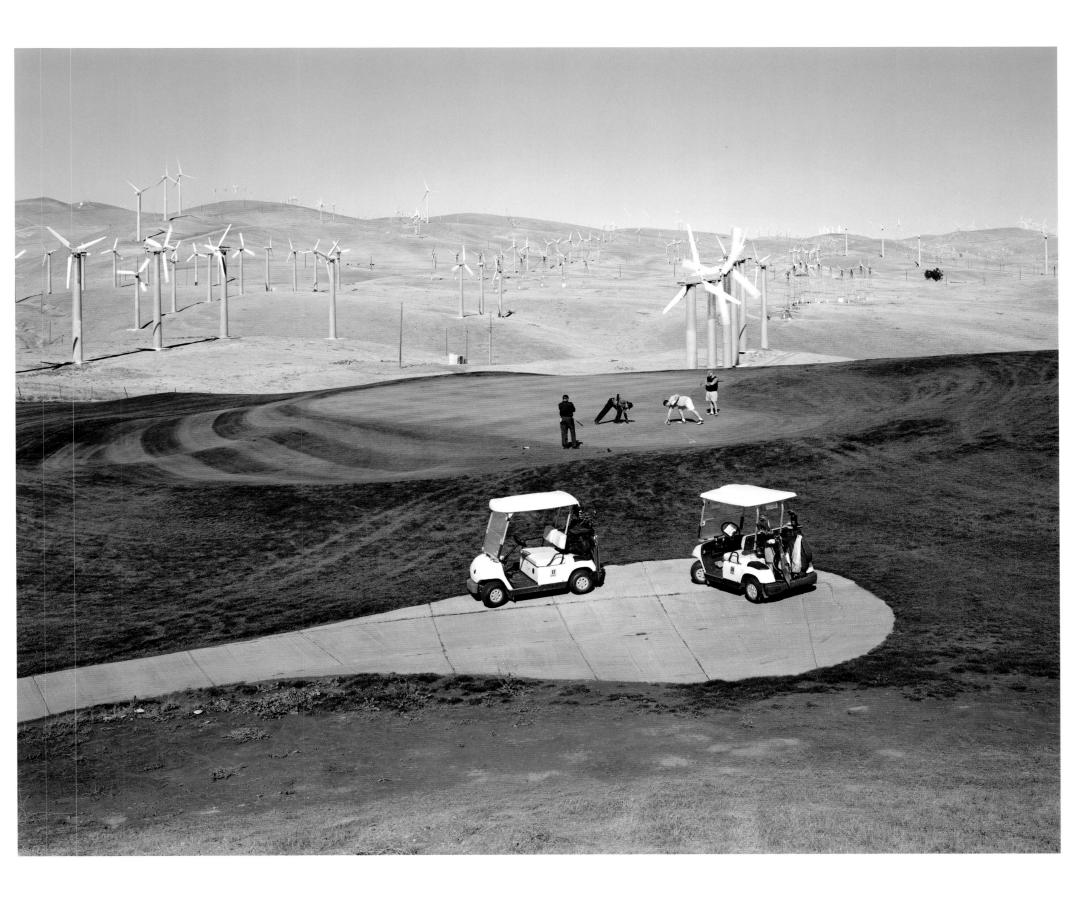

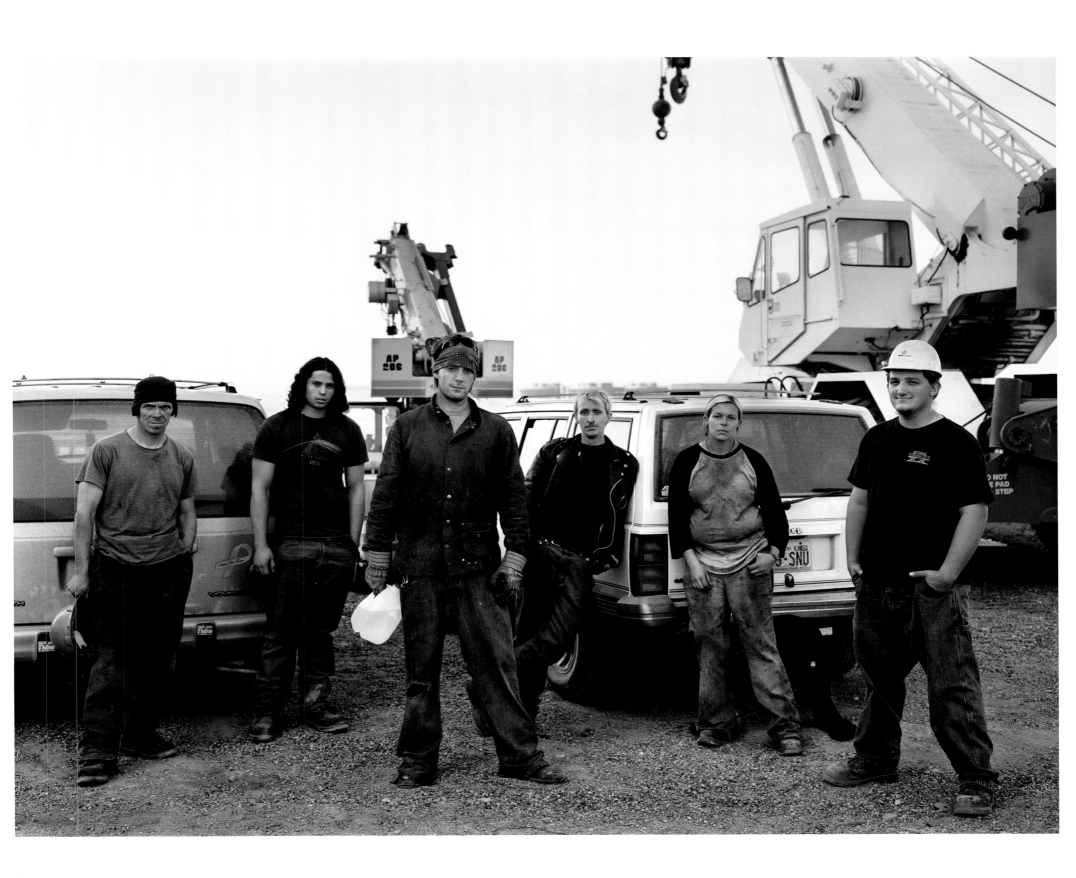

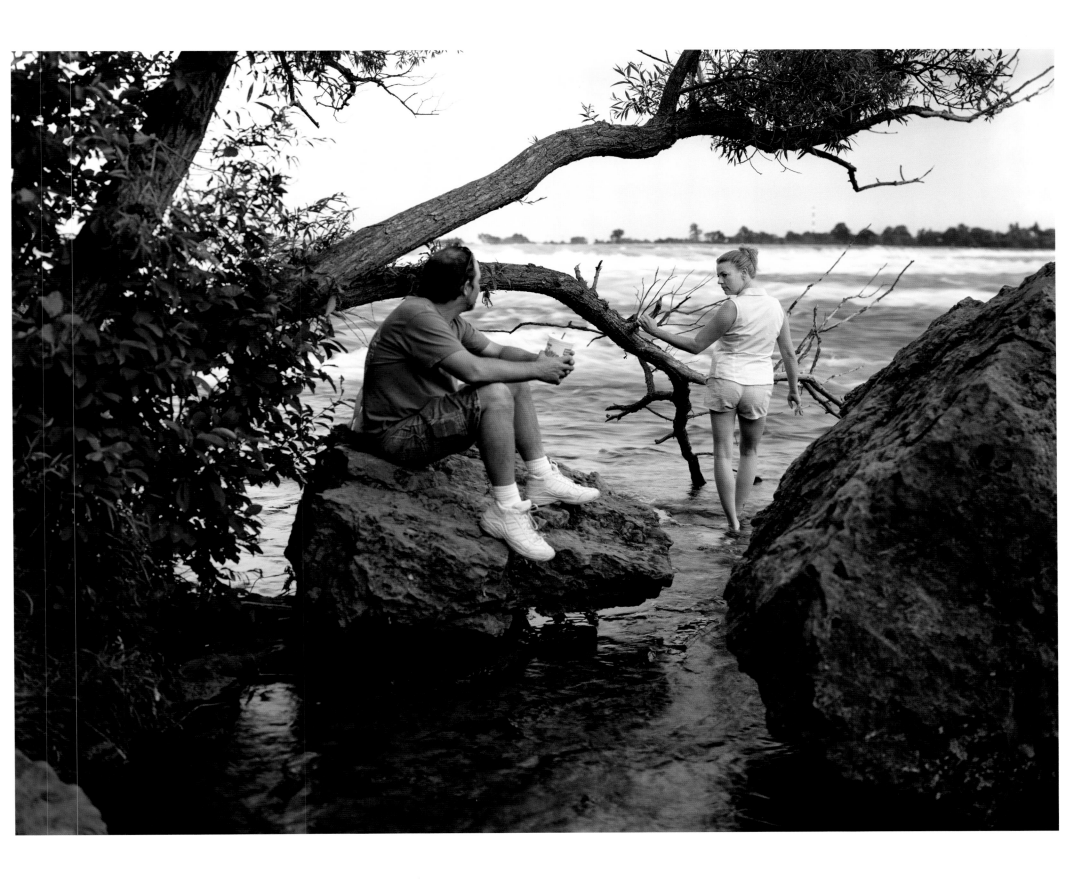

63 Century Wind Project, Blairsburg, Iowa 2008

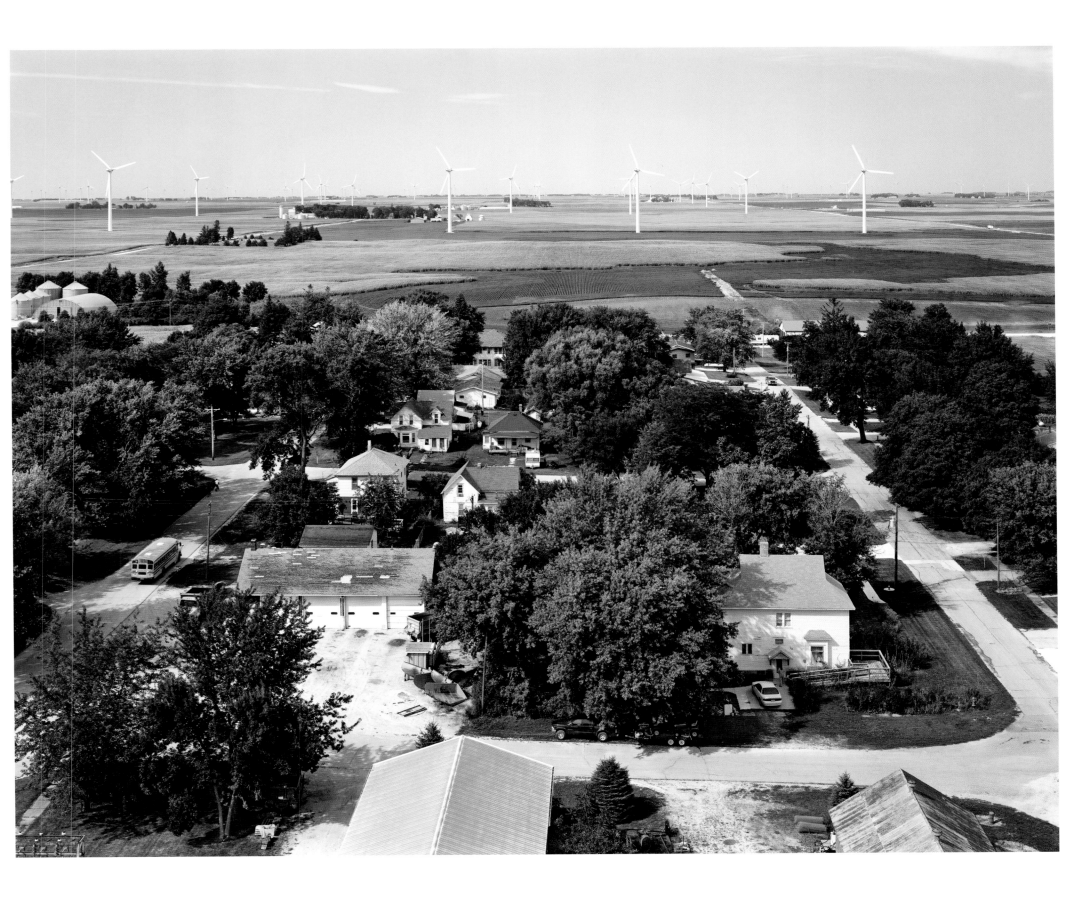

To see what is in front of one's nose needs a constant struggle.
— George Orwell

In Cheshire, Ohio, I watched backhoes crush whole houses into kindling in less than an hour. The destruction was so fast and easy, I had to remind myself these were real homes, not a child's cardboard constructions. At the local pizza shop, I photographed a newspaper that pictured a white clapboard house in front of a power plant; across the house's roof in black marker the shop owner had written "GONE."

It was the fall of 2003 and I had been hired to photograph a town in the process of being erased. The American Electric Power Company had paid residents of Cheshire a lump sum to leave, never come back, and never complain in the media or in court if they became sick from environmental contaminates spewed out of the AEP plant. The company was buying itself a lawsuit-free future. Back in New York, I could not get Cheshire out of my mind.

It was my visit with Beulah Hern that had made the deepest impression on me. Boots, as she called herself, was in her eighties and refused to sell her home. American Electric Power, she said, was harassing her for holding out, so she had taken her security in hand. Boots showed me two surveillance cameras installed at her window under a ruffled curtain. On top of her wooden television cabinet sat a video monitor. This enabled her to watch her favorite T.V. programs and simultaneously monitor her backyard for suspicious activity. Here I was in the home of a genteel elderly woman who could have been my grandmother, except that this grandma had taken extreme measures to protect herself. Her security set-up unnerved me. It mirrored the coal plant's security. Surveillance was everywhere in the tiny town of Cheshire. Boots sat down in her easy chair and watched me as I photographed her video cameras. "Would you like to see my gun?" she said, and from the side pouch of the chair, where I expected to find copies of Readers Digest and the Farmers Almanac, Boots pulled out a handgun. Sensing my alarm, she kindly unloaded it.

Six months later, in the spring of 2004, I began to make pictures of the production and consumption of energy in the United States. I wanted to photograph the relationship between American society and the American landscape, and energy was the linchpin; this much I had gleaned from Cheshire. Energy— how it was made, how it got used, and the ramifications of both— would therefore be my focus. For the next five years, I traveled the country making photographs at or near energy production sites: coal, oil, natural gas, nuclear, hydroelectric, fuel cell, wind, and solar. It was a strange kind of tourism: energy tourism. Everything I photographed related to energy, even if the link was not always obvious or simple. The electric chair in the Moundsville State Penitentiary, for instance, might appear incongruous to this series. Yet, aside from being an icon of electrical power usage, the chair presses the question: for what exactly are we importing all of this oil, burning all of this dirty coal, and drilling into our oceans and our national parks?

In my studio hung a giant map of the United States stuck with color-coded push-pins: red for coal, blue for nuclear, green for wind, yellow for "been there," and so on. My studio manager, Ryan Spencer, and I would plot my next trip while staring at the map. Before I could leave, dozens of queries went out to corporate public relations, plant managers, government bureaus, people living off the grid or stewing up bio-diesel, congressional aids, and cheap motels. The point of all that careful planning, though, was to set myself up for the unexpected. Having a clear plan was a ruse to launch me into the world and into the work. Much of the time, my favorite pictures were the result of serendipity.

Hurricane Katrina threw a painfully resonant wrench into my well-laid plans. I had already plotted a trip to Louisiana to photograph the offshore oil platforms and refineries along the Gulf Coast when the storm hit. Six weeks after the initial devastation, I went to see the rigs and what remained of the coastline. Even before this hurricane, scientists had connected the dots between

energy production, climate change, and an increase in deadly weather. Katrina was the ultimate symbol of how we, as a society, had failed; how our rapacious, "supersize-me" culture had led to catastrophe. The oil platform I photographed on Dauphine Island in Alabama was an unmoored mangle of bent and broken steel. It brought to mind a great prehistoric creature that has finally been crushed by something greater.

I traveled numerous times to photograph the repercussions of westward expansionism on the landscape. Mountains, rivers, and deserts there supported dams, power plants, highways, oil wells, and the occasional solar or wind farm. Humankind's technical prowess had etched itself into nature's grandeur. But settlers did not expect that their American Dream of material ease would ultimately require more energy than the land could give. The Hoover Dam, for instance, a supreme feat of hydro-engineering in the 1930s, has now become an emblem of nature's depletion. Looking at my photograph of the dam, it is hard not to be impressed by society's taming of the untameable: the harnessing of water to foster the growth of the American West. Pride is evident in the dam's magnificent architecture. But this depiction of human triumph also shows Lake Mead's diminishing waterline, known as "the bathtub ring." The ring is a result of a ten-year drought, as well as the siphoning off of water to nearby Las Vegas for luxury hotels and golf courses. Water itself has become more valuable than the electricity it can produce.

The wounds I discovered in the American landscape made me reconsider my own sense of entitlement and the American heritage of Manifest Destiny. These pictures question the human conquest of nature at any cost. Might we, as Americans, consider our obligation to nature and one another, not only our individual rights?

One right to which I cling, however, is the right to photograph in public space. Security and surveillance continually interfered with this right, and inadvertently influenced my pictures. There was a new sense of vulnerability in the U.S. after 9/11 and I expected to be questioned now and then. But I resented the systematic harassment I faced while I worked on *American Power*. Law enforcement officials more than once ran me out of town when I had done nothing remotely criminal. The result was that from 2003 to 2008 — a span that coincided with the Bush era — most of where I went in the United States to work, I went in fear. This was because my intentions ran counter to corporate interests, which had Homeland Security to back them up. I wanted to make the topic of energy more transparent, while big energy companies and their governmental counterparts shrouded themselves in secrecy.

The height of my security troubles came in the fall of 2004 when I returned to the Ohio River Valley. In Raymond City, West Virginia, more hamlet than city, a stranger proudly invited me into her backyard to, as she put it, "appreciate a better view of the cooling towers." A bench sat on the riverbank facing the Amos coal power plant. I imagined warm summer evenings when residents would drink a cold beer there and enjoy the view of the massive stacks as they belched toxic emissions into the sky above the Kanawha River.

In neighboring Poca, I set up my camera on a public sidewalk and twenty minutes later the flashing lights of a four-wheel police cruiser came towards me. A sheriff stepped out and shouted orders at me. As she ran a check on our driver's licenses, another four-wheeler pulled up. Another sheriff got out and asked to search my car: "You don't have a dead body in there, do you?" I handed him my rental keys, and watched him rummage through my belongings, nervous that he might light strike a sheet of exposed film. He returned with a stack of 4 x 5 black and white Polaroids as evidence against me. The Deputy and State Police had to be called now, he said, because I'd been photographing the power plant without authorization. I wanted to point out to him that I had been standing on public property, that I had been at a great distance from the plant, and that I also photographed an empty chair on the river's edge. But this was one of those times when you know that any comment you offer — however sensible — will make a bad situation worse.

Thirty minutes later, an unmarked car arrived. A middle-aged man in a suit and tie stepped out and flashed his I.D.: FBI. "You know," he said, "if you were Muslim, you'd be cuffed and taken in for questioning." Another unmarked vehicle pulled up, making the final count six vehicles and six law-enforcement officers. Passers-by must have thought there had been a murder.

I was becoming less sure that this would end with a laugh and apology on their part. Six officers huddled to discuss my fate. Five minutes later, the FBI agent returned to scold me: "you can't just go pointing your camera at these infrastructures anymore. Times are changing. Why didn't you tell me that you've been questioned for this kind of thing before?"

It was true—I had already gone through many interrogations by then. One resulted from a call the police had received in Shippingport, Pennsylvania reporting a man on Main Street carrying a missile launcher. The missile launcher was my tripod. A police officer escorted me out of town, explaining that the power company I was photographing didn't allow pictures. I had broken no law, however, having attempted to photograph a coal stack from a public street in the center of town. Apparently, Shippingport police now enforced corporate instead of Constitutional law. I was witnessing the Patriot Act in action.

On a later trip to West Virginia, a public relations officer at the Amos Coal Power Plant welcomed me warmly and allowed me to make pictures inside the facility. I was shocked. It turned out he was a photography buff and had a copy of one of my books. His cooperation was an exception. The cops and FBI let me go after the nearly two-hour interrogation in Poca, but henceforth I worked with a discomforting urgency, sensing Big Brother at my heels. At one point, I consulted my attorney, hoping I could find a legal argument to use against the next officers who would lawlessly eject me. "Don't get arrested at all costs," he counseled, less than reassuringly. "You don't want to end up in some small town jail that won't be easy to get out of."

Energy's symbiosis with politics was a given, so it made sense to visit my nation's capitol. Ironically, I photographed a nuclear warhead at the Department of Energy headquarters and a solar array at the Pentagon. Energy production is now a major concern of our military command, which is sponsoring several progressive renewable energy projects. I had expected an alternative energy display in the lobby of the Department of Energy, which is, after all, charged with overseeing domestic energy production, research, and conservation. Instead, the DOE lobby displayed a nuclear missile—a vestige of the Department's predecessor, the Atomic Energy Commission, which began in 1946 to grapple with the dangers of the recently unleashed nuclear bomb. I couldn't help think it was time to change the DOE lobby display.

With energy politics in mind, I also went to both political conventions in the late summer of 2008. The Republicans were holding theirs at the Xcel Energy Center; and the Democrats were boasting a "Green" event sponsored by the so-called "clean coal" industry. I nosed around the prison-like metal fencing that surrounded the hall in Denver, but never gained access. Neither did I get into the Xcel Center in St. Paul. I had tried hard for each, and with good connections. But I was not a photojournalist who would promote the events in the news, which made me unnecessary and a potential liability. By this time, I was used to getting rejected from official venues. This project was, in part, about *not* getting in. What I saw on the outside, though, was less predictable and more intriguing to me than the choreographed hoopla inside the halls. I made a picture of the Fox News electronic billboard outside the Xcel Center, which showed the approach of Hurricane Gustav. Gustav halted the RNC proceedings for a day and brought back horrible, and, for many politicians, embarrassing memories of their response to Katrina.

Between Denver and St. Paul, I photographed the energy landscape of the Midwest. I visited a strip mine in the Powder River Basin of Northeastern Wyoming, where coal's purported cleanliness eluded my camera, which I had to wipe laboriously to remove the soot after the shoot. Three months later, in amazement, I watched a Christmas time television ad run by the coal industry, in which several chunks of coal with cute blinking eyes cheerily sang:

Frosty the Coalman is a jolly happy soul,
He's abundant here in America and he helps our
 economy roll.
Frosty the Coalman's getting cleaner every day,
He's affordable and adorable and helps workers
 keep their pay.
There must have been some magic in clean coal
 technology,
For when they looked for pollutants there were
 nearly none to see . . .

Should we believe this ad made by an industry that stands to make billions if we do? Or listen to Nobel prize-winning energy expert Al Gore, who says clean coal is "imaginary."

In one of the strangest, most optimistic pictures here, a young inventor spins blue-white threads of electricity, as vivid as Zeus's thunderbolt, from a Tesla Coil. The Coil itself, invented in 1891, is a source of cheap, high voltage ignition. It is no answer to our energy dilemma, to be sure, but one of Mr. Lowrey's experiments may eventually lead to one. This electrical DJ embodies, for me, the grassroots ingenuity that has historically improved American lives.

About a year into making this series of pictures, I realized that power was like a Russian nesting doll. Each time I opened one kind of power, I found another kind inside. When I opened electrical power, I discovered political power; when I opened political power, I discovered corporate power; within corporate was consumer; within consumer was civic; within civic was religious, and so on, one type of power enabling the next. I began making these pictures with the idea that an artist lives outside the nesting doll, and simply opens and examines it. But now — while America teeters between collapse and transformation — I see it differently: as an artist, I sit outside, but also within, exerting my own power.

When I photograph, I do not consciously think about politics. But it was inevitable that the grim reality of American power circa 2003–2008 would find its way into my work. I could not ignore the security excesses, corporate avarice, and environmental indifference I encountered. I have tried to convey in these pictures the beauty and terror of early 21st century America, as it clings to past comforts and gropes for a more sensible future.

— Mitch Epstein, New York City, 2009

LIST OF WORKS

1 Amos Coal Power Plant, Raymond City, West Virginia 2004

2 Poca High School and Amos Coal Power Plant, West Virginia 2004

3 BP Carson Refinery, California 2007

4 Amos Coal Power Plant III, Winfield, West Virginia 2007

5 Vogtle Nuclear Power Plant, Waynesboro, Georgia 2006

6 Gavin Coal Power Plant, Cheshire, Ohio 2003

7 Cheshire, Ohio 2004

8 Omaha, Nebraska 2008

9 Beulah "Boots" Hern, Cheshire, Ohio 2004

10 Beulah "Boots" Hern's House, Cheshire, Ohio 2004

11 Reactor 9, Hanford Nuclear Reservation, Washington 2006

12 Grand Gulf Nuclear Power Plant, Mississippi II 2006

13 Grand Gulf Nuclear Regulatory Office, Mississippi II 2006

14 Signal Hill, Long Beach, California 2007

15 Wyodak Coal Mine, Wyoming 2008

16 Griffith Motors, The Dalles, Oregon 2006

17 Rancho Seco Nuclear Power Plant, Herald, California 2005

18 Big Bend Coal Power Station, Apollo Beach, Florida 2005

19 Moss Landing Power Plant, California 2007

20 Las Vegas, Nevada 2007

21 Yucca Mountain Nuclear Waste Repository, Nevada 2007

22 Port of Beaumont, Texas 2006

23 Fort Pierce, Florida 2005

24 Trans-Alaska Pipeline, Dalton Highway 2007

25 Hoover Dam Bypass Project, Nevada 2007

26 Gillette, Wyoming 2008

27 Ocean Warwick Oil Platform, Dauphine Island, Alabama 2005

28 Biloxi, Mississippi 2005

29 Martha Murphy and Charlie Biggs, Pass Christian, Mississippi 2005

30 Academy of Holy Angels Convent, New Orleans, Louisiana 2005

31 FEMA Trailer Camp, Gretna, Louisiana 2007

32 Louisiana Superdome, New Orleans 2005

33 Grand Gulf Nuclear Regulatory Office, Mississippi 2006

ACKNOWLEDGMENTS

Several people were essential to making *American Power*.
My deepest thanks to:

Susan Bell, for her sagacious reading of my photographs
and unrelenting faith. My essay is the fruit of our five-year long
discussion of power in America and her literary handiwork.

Ryan Spencer, my studio manager, for his boundless skill
set and invaluable insights.

Christoph Gielen, for his printing expertise, environmental
consciousness, and ardor, which more than once propelled
me forward.

Joseph Michael Lopez and Lee Satkowski, my shooting
assistants, for their collaborative spirit and keen thoughts.

Mark Nelson and David Zaza at McCall Associates,
for design acumen and nimbleness.

Kathy Ryan, at the *New York Times Magazine,* who commissioned
me to shoot the photo essay on Cheshire, Ohio that ignited this
project. I am grateful for her long-standing support.

The Steidl team — especially Michael Mack and Julia Braun.
Special thanks to Gerhard Steidl for his loyalty and vision.

Everyone at Laumont Digital, and, above all, Esteban Mauchi,
for his masterful prints.

My gallerists, who have shown and supported *American Power*:
Brent Sikkema, Michael Jenkins, Erin O'Rourke, and Meg Malloy
at Sikkema Jenkins & Co; Thomas and Christina Zander at
the Zander Galerie; Rodolphe and Sebastian Janssen at Galerie
Rodolphe Janssen; Isabella Brancolini and Camilla Grimaldi
at BrancoliniGrimaldi; and Anna Walker at Jackson Fine Art.

Thanks to The American Academy in Berlin, and, in particular,
Gary Smith. My AAB fellowship gave me a valuable chance
to reflect on American Power from outside America, and in one
of the most environmentally conscious cities in the world.

The following friends, family members, and colleagues offered
encouragement and good ideas: Neale Albert, Tina Barney,
Lucia Bell-Epstein, Marc Joseph Berg, Ruth Epstein, Wendy
Ewald, Marcel Feil, Peter Fleissig, Yvonne Force-Villareal,
Michael Fried, Joanna Lehan, Yancey Richardson, Andrew
Roth, Vicki Sambunaris, David Schwab, Mikio Shinagawa,
Carol Squiers, Alex Stark, Elisabeth Sussman, Brian Wallis,
and Sylvia Wolf; a special thanks to Eliot Weinberger and
Donna Wingate for their expert advice.

Finally, thanks to the photographers who have previously exam-
ined the American landscape, whose work was and remains an
inspiration to me — especially Robert Adams.

AMERICAN POWER

Orwell quote excerpted from THE COLLECTED ESSAYS, JOURNAL-
ISM AND LETTERS OF GEORGE ORWELL, VOLUME IV: IN FRONT
OF YOUR NOSE, 1945-1950, edited by Sonia Orwell and Ian Angus.
© 1968 by Sonia Brownell Orwell, renewed 1996 by Mark Hamilton.
Reprinted by permission of Houghton Mifflin Harcourt Publishing
Company. All rights reserved.

Edited by Susan Bell and Ryan Spencer
Design: McCall Associates, New York
Photographic prints: Esteban Mauchi/Laumont Photographics
Photographic print consultant: Christoph Gielen
Color separations: Steidl's digital darkroom, Reiner Motz
Production: Julia Braun, Bernard Fischer, Gerhard Steidl
Printing: Steidl, Göttingen
Scans: Steidl's digital darkroom and Laumont Photographics
Typeset in Adobe Opentype Akzidenz Extended; and
in American Power, drawn for this book by Mark Nelson

First edition published in September 2009
© 2009 for this edition: Steidl Publishers
© 2009 for all photographs:
Black River Productions Ltd./Mitch Epstein
Afterword © 2009 Mitch Epstein

Steidl
Düstere Strasse 4
37073 Göttingen, Germany
Phone: +49 551 49 60 60
Fax: +49 551 49 60 649
mail@steidl.de
www.steidlville.com | www.steidl.de

ISBN 978-3-86521-924-4

Printed and bound in Germany

WITHDRAWN